D1535942

UNFORGOTTEN
NEW YORK

UNFORGOTTEN NEW YORK

LEGENDARY SPACES OF THE TWENTIETH-CENTURY AVANT-GARDE

David Brun-Lambert
John Short
David Tanguy

Foreword by Lawrence Weiner

Prestel

Munich • London • New York

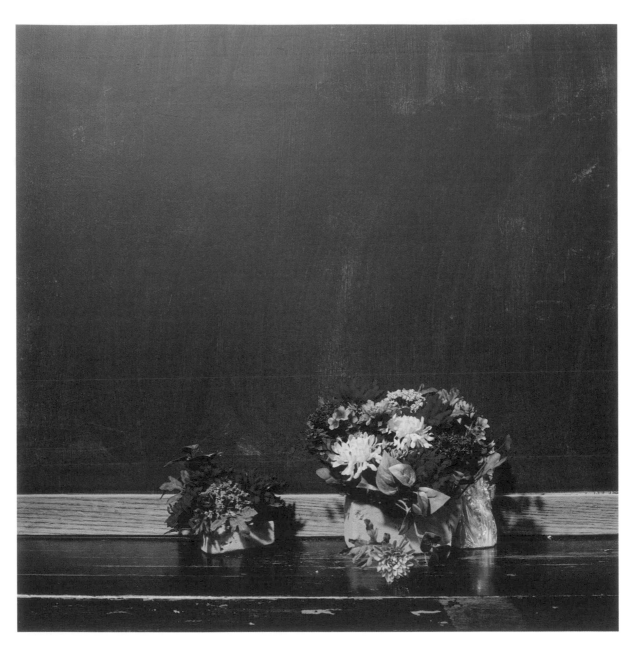

Inside 24 Bond Street, home of the Gene Frankel Theatre
and Film Workshop, formerly Studio Rivbea (see p. 66).

CONTENTS

A PLACE AT THE BAR

COMING OF AGE IN NEW YORK THERE WERE RUMORS

RUMORS THAT THE PEOPLE WHO FORMED THE IRISH REPUBLIC CONGREGATED AT AN IRISH BAR ON THE EDGE OF CHINATOWN

RUMORS THAT IN A BAR ON WASHINGTON SQUARE ALL OF THE ABSTRACT EXPRESSIONIST HEROES WERE CONGREGATED

RUMORS THAT IN A BAR NEAR MIDTOWN ALL OF THE PHOTOGRAPHERS & MODELS ONE HAD EVER SEEN IN THE MAGAZINES CONGREGATED

IN FACT THERE WERE RUMORS

IN FACT THERE WERE RUMORS

COMING OF AGE IN NEW YORK ONE SOUGHT THOSE PLACES HERE & THERE

THERE WERE POCKETS IN THE NIGHT OF PLACES WHERE THE SYNTAX WAS THAT OF ALL YOUR ASPIRATIONS

YOUR PRESENCE WAS YOUR PASSPORT

THE NAMES OF THOSE YOU QUOTED AS YOU DETERMINED YOUR FATE HAD A FORM & A SUBSTANCE

FINDING ONE OF THESE HAVENS LED TO FINDING ANOTHER & THE NEXT

IN THE QUEST TO FIND A COMMUNITY WHERE WHAT WAS DONE
WAS THE SUBJECT

THE EBB & FLOW OF THE SCENE MORPHED AS THE NEEDS & DESIRES
OF THE PATRONS CHANGED

WHEN A SITUATION TROPED ANOTHER VENUE AFFORDED ITSELF

THE VERY NATURE OF THE STRUCTURES REQUIRED THE INFLUX
OF NEW PEOPLE & NEW IDEAS

LEAVING BEHIND THE BAR OR THE CLUB THAT SLID INTO
AN ENTROPIC EXCLUSIVITY

MEMBERSHIP IN ONE MEANT ENTRANCE INTO ALL

A WORLD (PERHAPS A DEMI—MONDE) WAS BORN

AS THE WORLD TURNS EACH TWIST & TURN BEGETS
ANOTHER FORM

PERHAPS RETURNING TO THE STATE OF A RUMOR HERE
A RUMOR THERE FOR SOMEONE SOMEWHERE SOMEHOW
SOMEWHAT COMING OF AGE

LAWRENCE WEINER NEW YORK CITY 2015

INTRODUCTION

In the mid-twentieth century, New York City was the center of the world's cultural avant-garde. Artists traveled across America and from further afield to experience the buzz of the city and to be part of the scene. The musical styles of folk, free jazz, hip hop, disco, No Wave and punk all evolved from the city's streets. It was a fertile ground for literature, too, providing inspiration for the works of writers ranging from Norman Mailer and Arthur Miller to William S. Burroughs and Allen Ginsberg. In the visual arts, the city witnessed the development of Abstract Expressionism via the paintings of Jackson Pollock and Mark Rothko, and the explosion of Pop art with the work of Jasper Johns, Andy Warhol, and Jean-Michel Basquiat. It also provided the atmospheric backdrop for a myriad of film-makers, from Jonas Mekas to Martin Scorsese.

As New York has continued to evolve, most of the city's historic and legendary clubs, lofts, studios, and galleries have long since disappeared. In their place, parking garages, restaurants, and offices have emerged: functional spaces with few traces of what preceded them. Seemingly, the spaces that performed such crucial roles in the creative process have been reappropriated, redeveloped, and mostly forgotten.

Born out of the partnership of a writer, a photographer, and a designer, this book is both a photographic and an editorial investigation. It takes the reader on a journey through the physical locations that played host to key moments in New York City's avant-garde culture from the 1950s to the late 1980s. For two years, hoping to capture some traces of the city's vanished glory, the three of us knocked on many doors in order to gain access to these mythical places. Once inside, we discovered that some had been completely redeveloped, while others had changed only cosmetically and were still being used for a similar purpose. To our surprise, a few remained completely unchanged.

Through this process of exploration, we were fortunate to meet some of the people who had participated in the artistic adventures we were interested in. While they provided us with first-hand accounts of specific happenings, they also highlighted the relevant political, social, and cultural developments of the eras in question. We soon became aware that it was these factors, mixed with the exceptional talents of certain individuals, which led New York City to become the birthplace of global pop culture.

David Brun-Lambert, John Short, and David Tanguy

NIGHTLI

AND

CLUBB

FE

ING

"There is something in the
New York air that makes sleep useless."

Simone de Beauvoir

PARADISE GARAGE

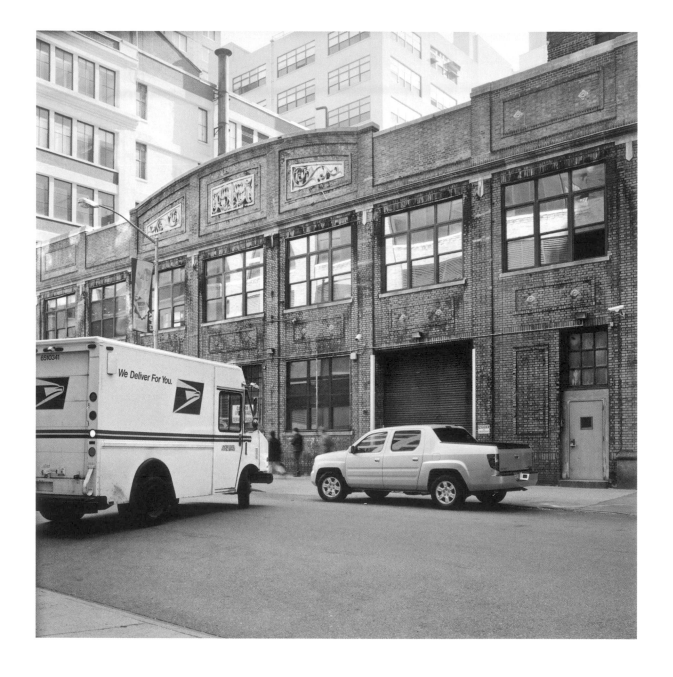

THE KING OF CLUBS
Home of celebrated DJ Larry Levan

In 1977, club promoter Michael Brody and his former lover Mel Cheren, the owner of disco label West End Records, joined forces to open a nightclub on the 25,000-square-foot first floor of a disused garage in the then-deserted Hudson Square area. Inspired by the parties thrown by David Mancuso at The Loft, they applied a strict door policy: gay and straight customers were admitted on Fridays; Saturday was strictly gay only; entry was with membership cards only; no alcohol was allowed or food served.

Paradise Garage helped shape modern club culture. Dreamed up by its founders as a temple for disco music, it fully embodied its philosophy of peace, love, and equality. The legend of the club is inseparable from the figure of Larry Levan, who was the first person to make the club DJ the center of attention. Fueled by a powerful sound system designed specially for the venue by Richard Long, Levan is remembered for his ability to blend diverse kinds of music, fitting them together to create "garage," the disco and dance style he pioneered, which was an unusual mixture of disco, gospel, soul, rock, and pop.

For nine years, Paradise Garage was a multicultural and musical haven, hosting concerts by artists such as Grace Jones, Patti LaBelle, ESG, Gloria Gaynor, Sylvester, Madonna, Gwen Guthrie, and New Order, until its closure in September 1987. Five years later, Larry Levan died of heart failure caused by endocarditis, a type of inflammation of the heart. The building on King Street is now owned by broadband and telecommunications company Verizon.

A night at Paradise Garage, 1977.

FIVE PARADISE GARAGE ANTHEMS

Sister Sledge, "Lost in Music" (1979)
Inner Life feat. Jocelyn Brown, "Make It Last Forever" (1981)
Taana Gardner, "Heartbeat" (1981)
Gwen Guthrie, "It Should Have Been You" (1982)
Peech Boys, "Don't Make Me Wait" (1983)

STUDIO 54

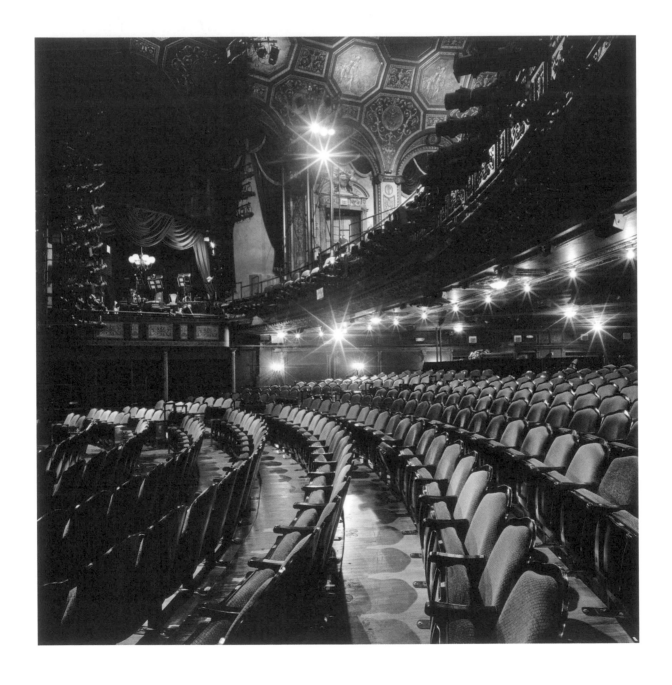

D-I-S-C-O

The world's most famous club

Though it operated for only four years (1977–81), Studio 54 left an indelible mark on the history of New York club culture. Originally the Gallo Opera House, the theater was acquired by the CBS radio network in 1942 before the broadcaster sold the building in 1976 when it decided to move its offices. In 1977, businessmen Steve Rubell and Ian Schrager bought the venue with the financial backing of Jack Dushey, for the low price of $400,000. With the help of interior designer Ron Doud and lighting designer Paul Marantz, they turned it into a nightclub.

After getting into trouble with the New York State Liquor Authority for selling alcohol without a license, Studio 54 caused quite a sensation when Bianca Jagger rode a white horse into the club, led by a naked man covered in white body paint, to celebrate her 30th birthday in May 1977. For that year's New Year's Eve party, as part of a collaboration with party planner Robert Isabell, 4 tons of glitter was thrown over the club floor. Studio 54 became the hippest club in Manhattan. Art and fashion luminaries, including Andy Warhol, Grace Jones, and Calvin Klein, went there to be seen.

The club's enormous success ultimately caused Rubell to make some poor decisions. In December 1978 he told the press that Studio 54 had earned more than $7 million in its first year, adding: "Only the Mafia made more money." Shortly thereafter, the IRS raided the place and Rubell and Schrager were arrested for tax evasion. The two men were sentenced to three and a half years in prison, which was then

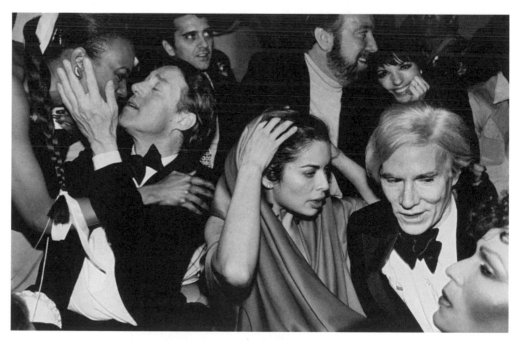

Celebrities during a New Year's Eve party at Studio 54, 1977. In front are Halston, Bianca Jagger, and Andy Warhol; behind them are Jack Haley, Jr. and his then-wife Liza Minnelli.

reduced to thirteen months. Studio 54 closed with a final party on February 4, 1980. In attendance were Diana Ross, Richard Gere, and Sylvester Stallone. On February 28, 1980, just 28 days after Rubell and Schrager went to jail, the club's liquor license expired. The papers claimed it was Stallone who had the last legal drink there. In March, the club was closed down by officials.

After reopening in the late 1980s under different names, including The Ritz and Cabaret Royale, the property became a concert venue for new wave, punk, and disco artists. In 1994 it reopened as a nightclub. The non-profit Roundabout Theatre Company bought the building in 2003. Since then, Roundabout has mounted shows there including *Cabaret*, *Assassins*, *Sunday in the Park with George*, and *Harvey*.

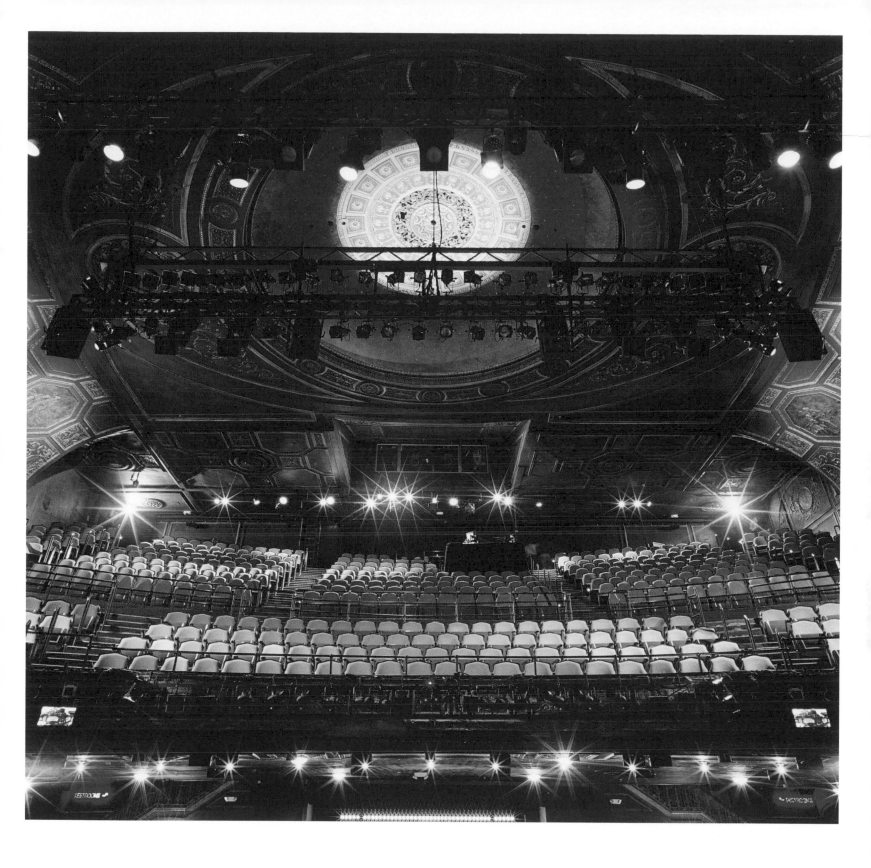

FIVE STUDIO 54 ANTHEMS

Chic, "Dance, Dance, Dance (Yowsah, Yowsah, Yowsah)" (1977)
Rose Royce, "Wishing on a Star" (1978)
Sylvester, "You Make Me Feel (Mighty Real)" (1978)
Gary's Gang, "Keep on Dancin'" (1979)
Hamilton Bohannon, "Let's Start the Dance" (1981)

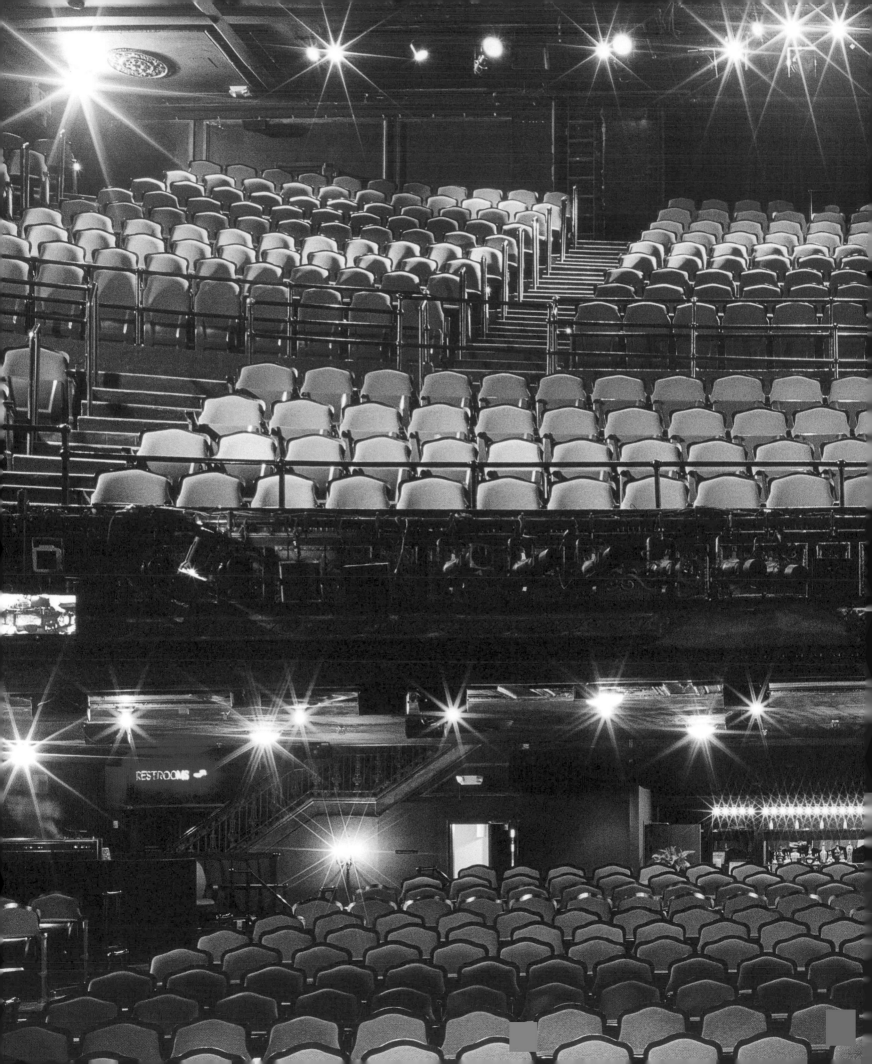

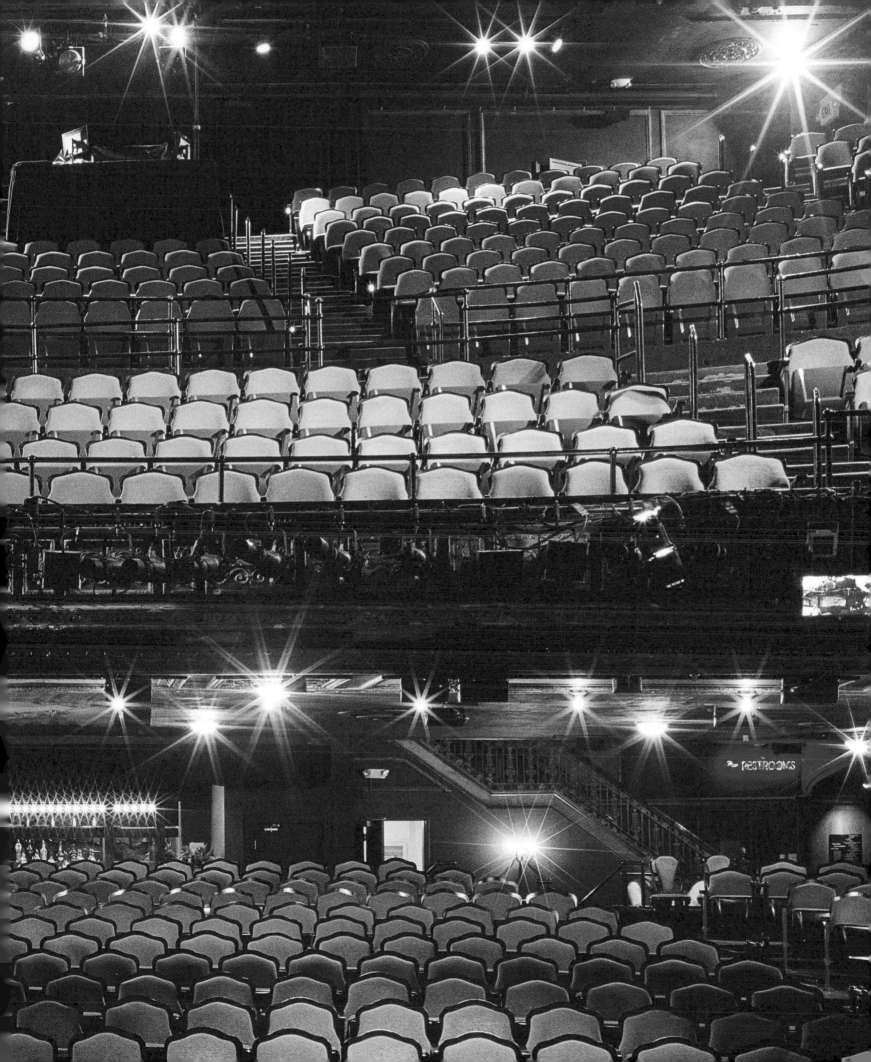

STONEWALL INN

OUT AND PROUD

The roots of gay pride

Contrary to popular belief, homosexuality was not illegal in New York at the end of the 1960s, even though the authorities acted as though it was. During the early years of the decade a New York State Liquor Authority law stated that alcohol could not be served in gay bars, but this ban was overturned in 1967. Shortly after, a New York court ruled that it was no longer against the law for two men to dance together in public. Among the gay hotspots in Greenwich Village, the bars and nightclubs The Purple Onion, Washington Square, and Tony Pastor's saw their attendance suddenly swell.

Yet despite this new tolerance toward the homosexual community, the NYPD continued to raid gay clubs, using a different law as an excuse: the requirement that any person in a public place must wear at least three articles of clothing in line with their gender. Until the summer of 1969 the police would regularly interrupt parties, temporarily close bars, arrest gay prostitutes in the streets, and terrorize underage homosexuals. The Gambino and the Genovese Mafia families, who controlled most of the gay venues in Manhattan, would often bribe police to stop targeting them. Things would go back to normal—until the next raid, as if nothing had ever happened.

The Stonewall Inn was accustomed to police intervention. Opened in March 1967 without a liquor license, and chronically dirty, the bar attracted a racially diverse clientele of drag queens, hippies, lesbians, gay kids, older homosexuals, and a few straight people. Former criminal Ed Murphy, a member of this tight-knit community, installed a system to alert patrons to the arrival of the police by flashing white lights onto the two dance floors. On June 28, 1969,

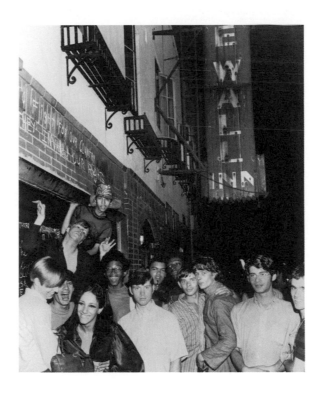

A group of young people celebrates outside the boarded-up Stonewall Inn after riots during the weekend of June 28–29, 1969.

however, the system failed. During a late-night/early-morning raid—the second in four nights—customers were ordered to exit the premises. One transvestite being escorted by police tried to escape, and was struck by them; people began to throw coins at the cops. A huge crowd formed outside the tavern, as bystanders stopped to watch, and members of the gay community arrived having heard about the raid. Soon, the police were being bombarded with glass bottles and trash by the crowd, angry at the police's treatment of the Stonewall clientele. In a panic, the officers locked themselves inside the Stonewall while, outside, several people uprooted a parking meter and used it to break down the door.

After this first night of rioting, four policemen were lightly injured and three people arrested. Rioting continued on Christopher Street for several nights; on the fifth night, more than 1,000 people fought 400 policemen with stones, shards, and projectiles. During the first days of July, when no police officer would run the risk of bullying a gay person in Greenwich Village, graffiti appeared on the Stonewall's storefront that read: "GAY PROHIBITION CORUPT$ COP$ FEED$ MAFIA." The gay liberation, activism, and pride movements, focused on gay freedom and equality, were born.

The Stonewall Inn still exists. The building and the surrounding streets were designated a National Historic Landmark by the US government in February 2000.

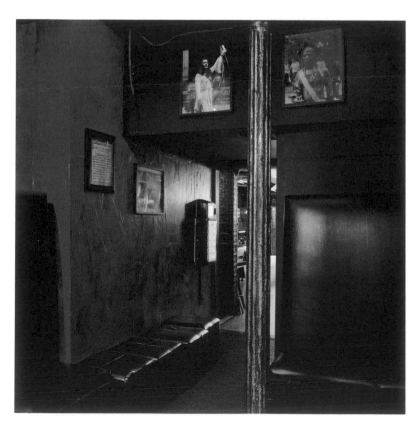

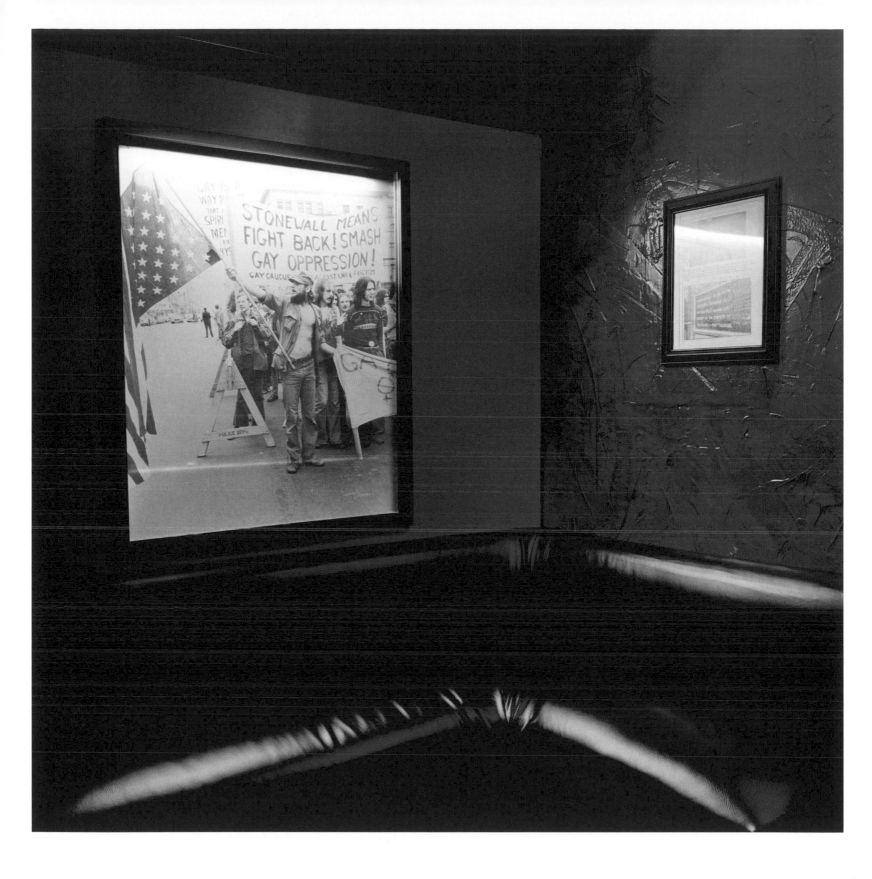

FIVE GAY ANTHEMS FROM THE 1950s, '60s, AND '70s

Judy Garland, "The Man that Got Away" (1953)
Shirley Bassey, "As Long as He Needs Me" (1960)
Dusty Springfield, "You Don't Have to Say You Love Me" (1966)
Liza Minnelli, "Maybe This Time" (1972)
South Shore Commission, "Free Man" (1975)

MUDD CLUB

NO WAVE HEADQUARTERS
Center of the 1980s underground scene

Between 1978 and 1983, Mudd Club played a pivotal role in New York City's underground club scene. Founded by Steve Mass, curator Diego Cortez, and downtown punk figure Anya Phillips, the club was named after Samuel Alexander Mudd, the doctor who treated John Wilkes Booth after he assassinated Abraham Lincoln. It was a gathering spot for all of Manhattan's post-punk artists (Jean-Michel Basquiat, Keith Haring); musicians (Debbie Harry, Klaus Nomi, Lou Reed, David Byrne, The B-52's, John Lurie, Nico); film-makers (Amos Poe, Vincent Gallo); and art world idols (Andy Warhol, William S. Burroughs).

Located in the artist Ross Bleckner's private loft, Mudd Club was supposed to offer an alternative to Studio 54 (see p. 16). This avant-garde cabaret housed a bar, gender-neutral bathrooms, a gallery designed by Keith Haring on the fourth floor, and a dance floor brought to life by DJs David Azarch, Anita Sarko, and Johnny Dynell, who played a mixture of punk, funk, and new wave tracks. The venue also became the No Wave movement's unofficial headquarters, hosting shows by bands such as DNA, Gray, and James Chance and the Contortions.

In 1981, Steve Mass started to host most of his events at Club 57 in the East Village, and two years later Mudd Club closed its doors. The club is mentioned in the songs "Life During Wartime" by Talking Heads and "The Return of Jackie and Judy" by the Ramones. Today, 77 White Street is divided into several private apartments; what used to be the Mudd's dance floor is now a ritzy condo.

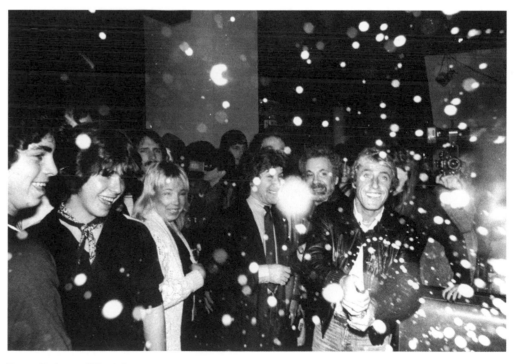

Roger Daltrey of The Who has a beer fight with photographers and the crowd during the premiere of the film *Quadrophenia* at Mudd Club, October 30, 1979.

FIVE MUDD CLUB ANTHEMS

James Chance and the Contortions, "Contort Yourself" (1979)
ESG, "Moody" (1982)
Konk, "Baby Dee" (1983)
Liquid Liquid, "Optimo" (1983)
Quando Quango, "Love Tempo" (1985)

ELECTRIC CIRCUS / DOM

A MULTIMEDIA POP EXPERIMENT

Where the concept of the "modern club" was invented

Between 1967 and 1971, Electric Circus was an underground nightlife hotspot. The building was formerly named Arlington Hall, a German community center and ballroom that hosted weddings and meetings in a district that had long been populated by German immigrants. The Polish National Home purchased the building in the late 1920s; 40 years later, it was transformed into one of the most unexpected clubbing locations in Manhattan.

In 1966, Andy Warhol and Paul Morrissey transformed the restaurant on the top floor of the building into a nightclub called the Dom (after Dom Polski Narodowy, "Polish National Home"). This is where Warhol hosted his "Exploding Plastic Inevitable" events, starring The Velvet Underground and featuring films, light shows, and happenings. Opened in 1967, Electric Circus casually mixed jugglers, trapeze artists, strobe lights, and video projections around a huge dance floor. Guided by the experimental approach favored by its founders Jerry Brandt and Stanton J. Freeman, it invented a new type of club culture that in the 1970s would inspire the disco scene, then in its infancy. Wide open to various kinds of music, Electric Circus hosted concerts by the Grateful Dead, Blue Öyster Cult, Sly and the Family Stone, and even an avant-garde recital by Terry Riley.

The building on St. Mark's Place is now a supermarket, open 24 hours a day, with a Chinese restaurant on its top floor; the whole street is now a major tourist destination.

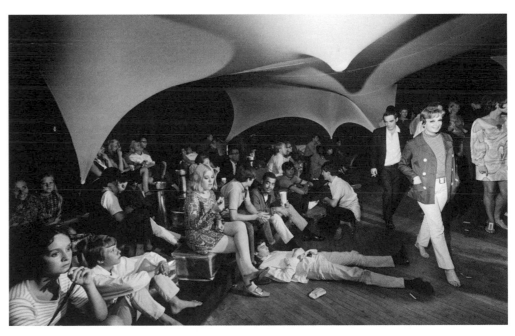

A night at Electric Circus, 1967.

FIVE SONGS PLAYED AT ELECTRIC CIRCUS / DOM

Terry Riley, *In C* (1964)
The Velvet Underground, "All Tomorrow's Parties" (1967)
Sly and the Family Stone, "Dance to the Music" (1968)
The Allman Brothers Band, "Midnight Rider" (1970)
Grateful Dead, "Ripple" (1970)

ROXY NYC

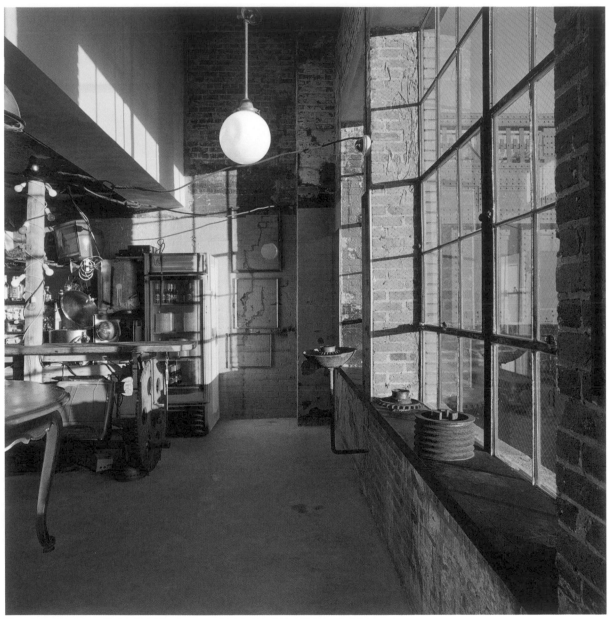

Björn Roth, Oddur Roth and Einar Roth, *Roth New York Bar*, 2013, mixed media installation with video.

ROCK IT!
First major hip hop club in the US

> "When Kool Lady Blue finally found a new home for her Wheels of Steel night, her club became the steamy embodiment of the Planet Rock ethos ... To its ecstatic followers, the Roxy would become a club that changed the world."
>
> Jeff Chang, *Can't Stop, Won't Stop: A History of the Hip-hop Generation* (New York, 2005)

Roxy NYC, or The Roxy, was Manhattan's most important club in the early days of hip hop, serving as the movement's unofficial headquarters. Hip hop culture, born in the South Bronx's housing projects during the mid-1970s, hit mainstream American audiences for the first time with the singles "Rapper's Delight" by The Sugarhill Gang in 1979 and "The Message" by Grandmaster Flash and the Furious Five in 1981. However, rappers and DJs did not have a space in Manhattan in which to practice, with the exception of Negril, a tiny Jamaican club in Greenwich Village.

In June 1982, British promoter Ruza Blue (also known as Kool Lady Blue) convinced the owners of The Roxy, a failing downtown roller rink and disco, to let her turn it into a nightclub and host the first big hip hop parties in Manhattan. She invited musicians such as Grand Mixer DST, Grandmaster Flash, Afrika Bambaataa, and Grand Wizzard Theodore to perform there, and showcased breakdancing, MC battles, and graffiti art, allowing the artists to create their works live, on large canvases laid against the walls.

Roxy NYC also hosted one of the city's largest weekly gay dance nights. Junior Vasquez and Frankie Knuckles were among the DJs who played at these parties, which were promoted by John Blair. As well as hip hop, the club also hosted concerts and performances by artists including Madonna, George Clinton, Grace Jones, Chaka Khan, and Yoko Ono. The venue continued to run as a nightclub and live venue until it closed on March 10, 2007; in 2013, Hauser & Wirth opened an art gallery in the space.

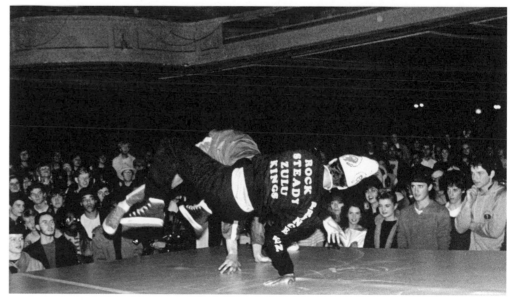

Members of the breakdancing team Rock Steady Crew in action at Roxy NYC, 1982.

"The Roxy was the first big downtown party that happened on a weekly basis. Kool Lady Blue organized parties with some of the most important hip hop stars in the city. The Rock Steady Crew was there every time. Grand Mixer DST and Afrika Bambaataa were regular DJs there. You'd go and you wouldn't be finished until five in the morning!"

Henry Chalfant, pioneering hip hop photographer, interview with David Brun-Lambert

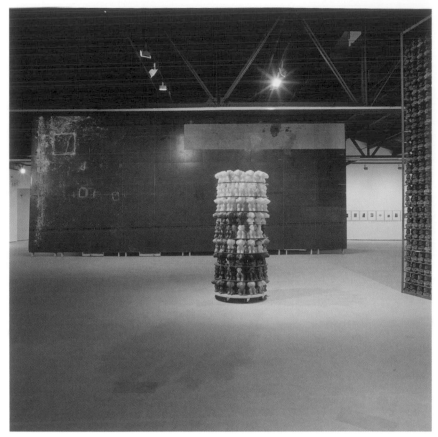

'Dieter Roth. Björn Roth,' January 23–April 13, 2013, installation view, Hauser & Wirth.

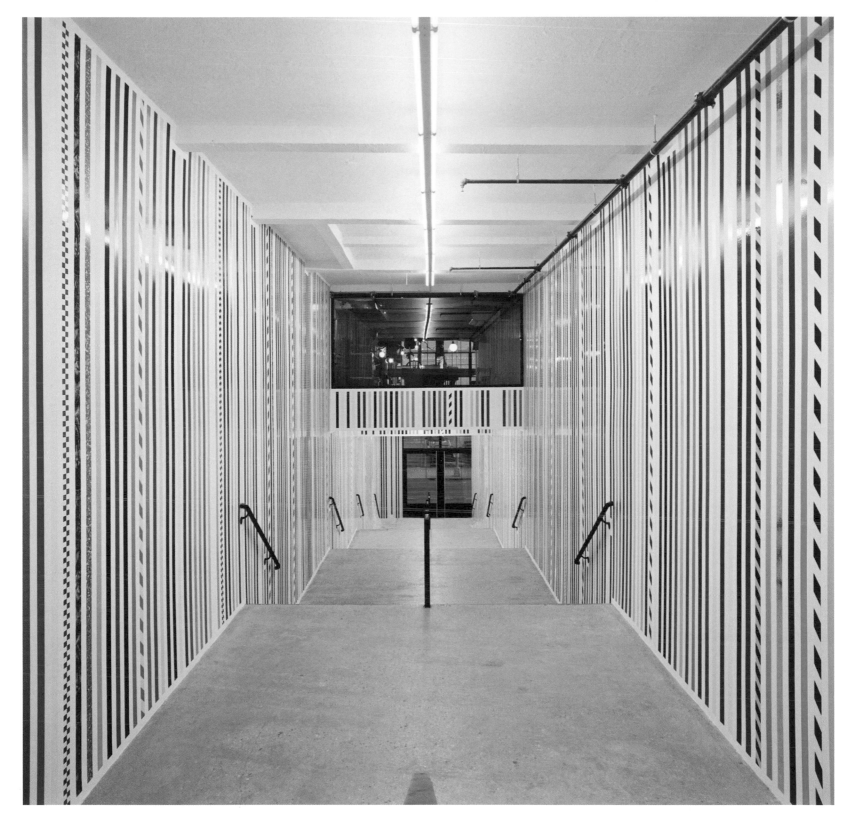

Martin Creed, *Work No. 1461*, 2013, 2-inch wide adhesive tape strips, installation view, Hauser & Wirth.

FIVE ROXY NYC ANTHEMS

The Sugarhill Gang, "Rapper's Delight" (1979)
Kurtis Blow, "The Breaks" (1980)
Afrika Bambaataa & The Soulsonic Force, "Planet Rock" (1982)
Grandmaster Flash and Melle Mel, "White Lines" (1983)
Hashim, "Al-Naafiysh (The Soul)" (1983)

SANCTUARY

HEAVENLY GROOVE
The first "official" gay club in the US

Founded in 1969 by Arnie Lord in a converted German Baptist church in Hell's Kitchen, Sanctuary was the first totally uninhibited gay discotheque in America. Its legal maximum occupancy was set at 346 people, but most of the time the club welcomed a crowd of more than a thousand, mingling conservative wealthy men, suburban kids, and prostitutes.

The club owner intentionally kept the religious decor—stained glass and sculptures of saints—intact, and added Christian imagery with subtle erotic and edgy undertones. From the booth situated in the altar's place, Francis Grasso became the first DJ to mix records together into one uninterrupted groove. In one of his most famous mixes, he simultaneously played a percussion-heavy song and the psychedelic, orgasmic break in "Whole Lotta Love" by Led Zeppelin. It produced a highly erotic tribal groove; the crowd went completely crazy for it.

Sanctuary was famously featured in Alan J. Pakula's movie *Klute* (1971) before closing in April 1972. Its later incarnations have included a methadone clinic, the Chelsea Theater Center and, since a major refurbishment of the two theaters in 1991, the Westside Theatre, host to acclaimed productions such as *I Love You, You're Perfect, Now Change* and *The Vagina Monologues.*

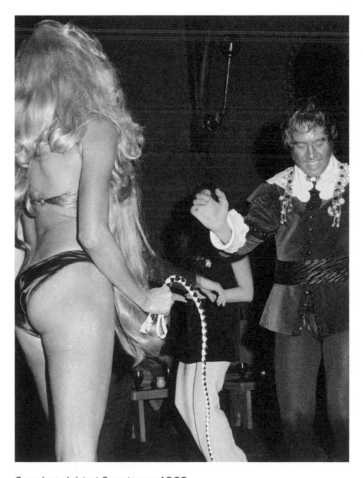

Opening night at Sanctuary, 1969.

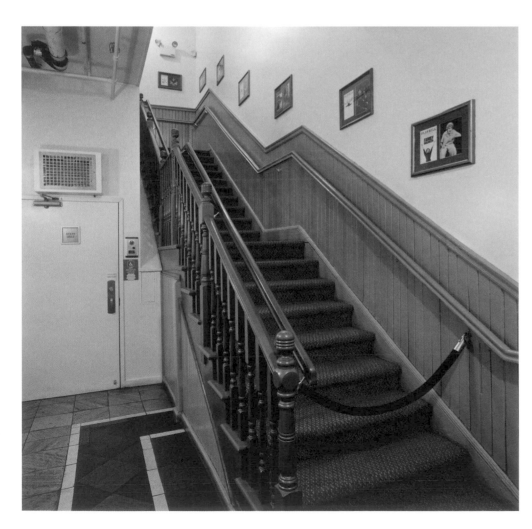

FIVE TRACKS PLAYED BY FRANCIS GRASSO AT SANCTUARY

Chicago Transit Authority, "I'm a Man" (1969)
Sly and the Family Stone, "Life and Death in G and A" (1969)
James Brown, "Get Up (I Feel Like Being a) Sex Machine" (1970)
Led Zeppelin, "Immigrant Song" (1970)
The Staple Singers, "I'll Take You There" (1972)

COPACABANA

BOURBON, CIGARS, AND SOUL
Home of the Rat Pack and Motown

A historic club in Manhattan that was open for almost twenty years, Copacabana hosted the who's who of New York. Though the club was officially operated by Monte Proser when it opened on November 10, 1940, it was in fact under the control of Mafia boss Frank Costello, who maneuvered to install his henchman Jules Podell as its head in 1948. Copacabana boasted Brazilian decor, Chinese food, a Latin big band, and the eccentric Copacabana Girls revue. The club became famous thanks to frequent appearances by the Rat Pack: Frank Sinatra, Sammy Davis, Jr., Peter Lawford, Joey Bishop, and Dean Martin, who performed duets with Jerry Lewis several times there during the 1950s.

Although it owed its fame to shows by African American artists such as James Brown, Nat King Cole, Al Green, Sam Cooke (who recorded the live album *Sam Cooke at the Copa* there in July 1964), and most Motown singers, including The Supremes, The Temptations, Marvin Gaye, and Martha and the Vandellas, Copacabana had actually enforced a "no blacks" policy when it first opened.

The club was also a home for New York's salsa scene. Willie Colón, Celia Cruz, Eddie Palmieri, and Tito Puente all performed there several times when the salsa wave, launched in Spanish Harlem and The Bronx, finally hit Manhattan. The nightclub closed in the early 1970s before reopening in 1976 as a classic 1970s discotheque; Barry Manilow's hit song 'Copacabana' was released in 1978. The club moved out of the building in 1992. For many years the space was home to the restaurant Rouge Tomate; it is now temporarily unoccupied.

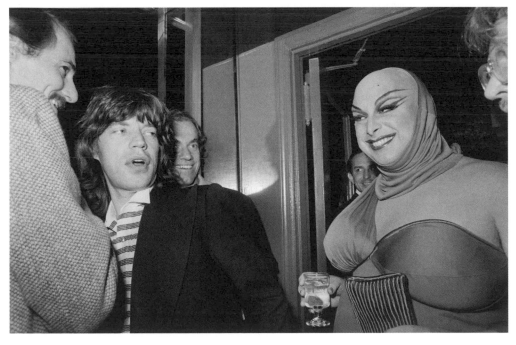

Mick Jagger and Divine attending Andy Warhol's
pre-opening party at Copacabana, October 14, 1976.

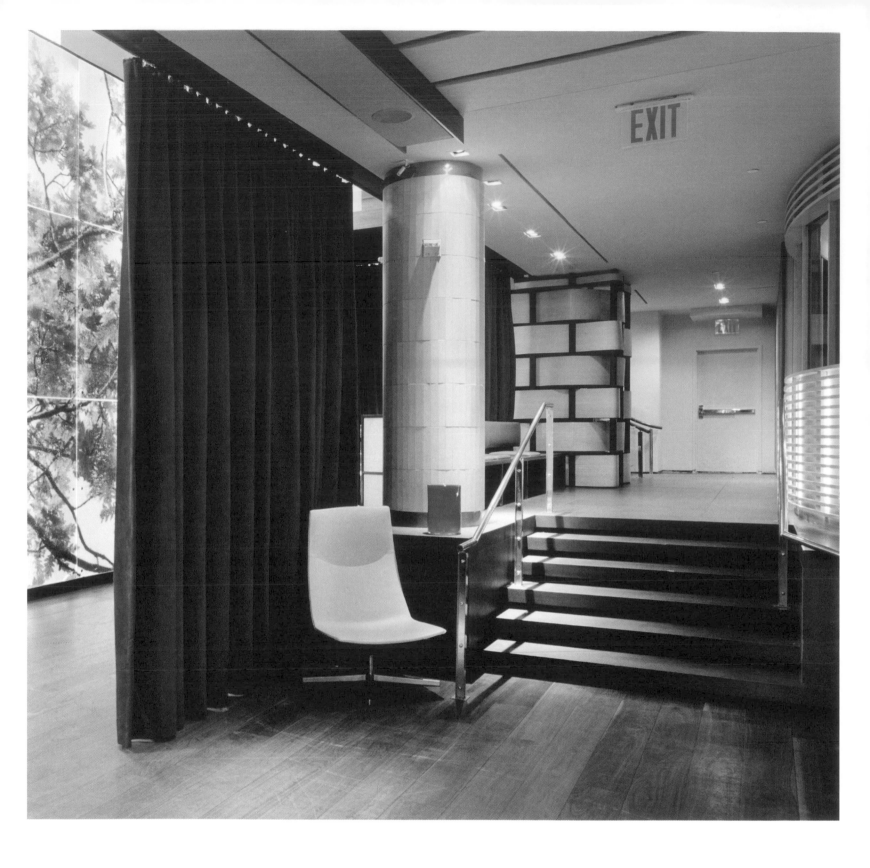

FIVE FILMS STARRING THE RAT PACK

Ocean's 11 (dir. Lewis Milestone, 1960). Starring Frank Sinatra, Dean Martin, Sammy Davis, Jr., Peter Lawford, and Joey Bishop
Sergeants 3 (dir. John Sturges, 1962). Starring Frank Sinatra, Dean Martin, Sammy Davis, Jr., Peter Lawford, and Joey Bishop
Robin and the 7 Hoods (dir. Gordon Douglas, 1964). Starring Frank Sinatra, Dean Martin, Sammy Davis, Jr., and Bing Crosby
Marriage on the Rocks (dir. Jack Donohue, 1965). Starring Frank Sinatra and Dean Martin
Cannonball Run II (dir. Hal Needham, 1984). Starring Frank Sinatra, Dean Martin, Sammy Davis, Jr., and Shirley MacLaine

"There is no place like it [New York], no place
with an atom of its glory, pride, and exultancy. It lays
its hand upon a man's bowels; he grows drunk
with ecstasy; he grows young and full of glory, he feels
that he can never die."

Walt Whitman

THE GYMNASIUM

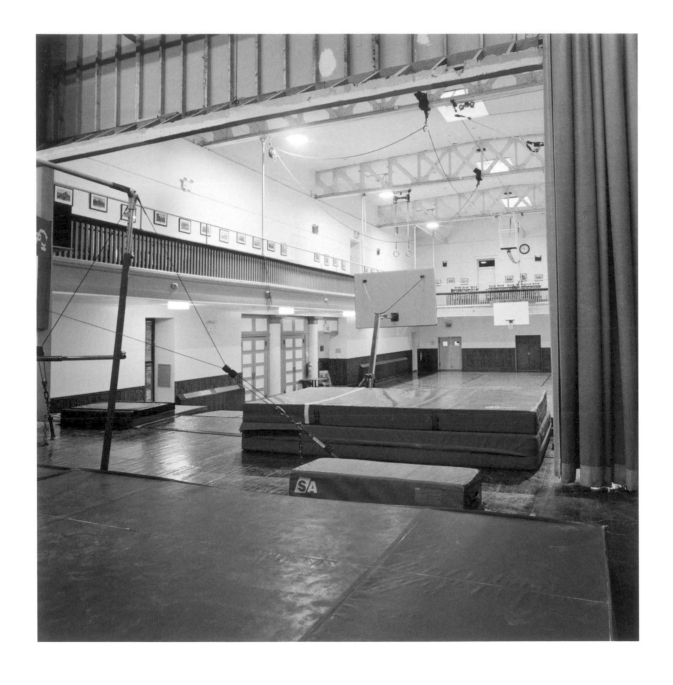

POP GYM
Hosted the first Warhol-organized Velvets gig

Starting on March 24, 1967, just over a year after the launch of the "Exploding Plastic Inevitable" shows, Andy Warhol held weekly concerts by The Velvet Underground in The Gymnasium, also known as Sokol Hall, a Czech and Slovak community center built by architect Julius Franke in 1896. The band's album *The Velvet Underground & Nico* had just been released, and Chris Stein (future co-founder of Blondie) opened for the band for a few concerts. "Work Out at The Gymnasium," said the flyer published by Warhol for the occasion. These shows continued for just over a month, but they were not successful. They were located too far from the hangouts favored by the cool Max's Kansas City crowd, and the roomy space was hard to fill for bands with only small fan bases. The concerts at The Gymnasium reached a turning point when The Velvet Underground started to free themselves from Warhol's influence.

Over 100 years after its construction, The Gymnasium has barely changed. It is still a gym and community center, and entering it is like taking a step back in time. The bar near the entrance features trophies, black wood, and a cozy atmosphere. There's a large gym with a second-story skylight that dominates the building. A floor above, you can still admire the graceful balconies that encircle the gym, with dozens of pictures and paintings depicting landscapes of the Czech Republic, dating back to the early 1920s. A little further, on the second floor, you'll find the restored 1896 meeting room, the library, and the pale-blue ballet room.

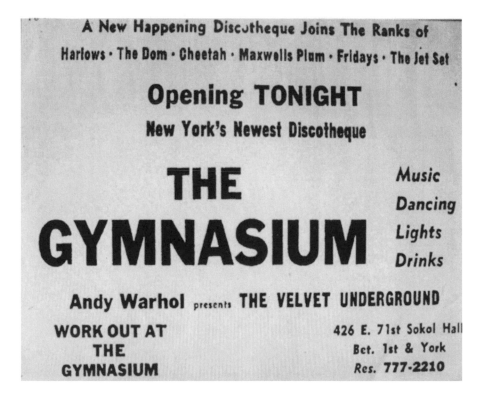

Advertisement for The Velvet Underground at The Gymnasium, 1967.

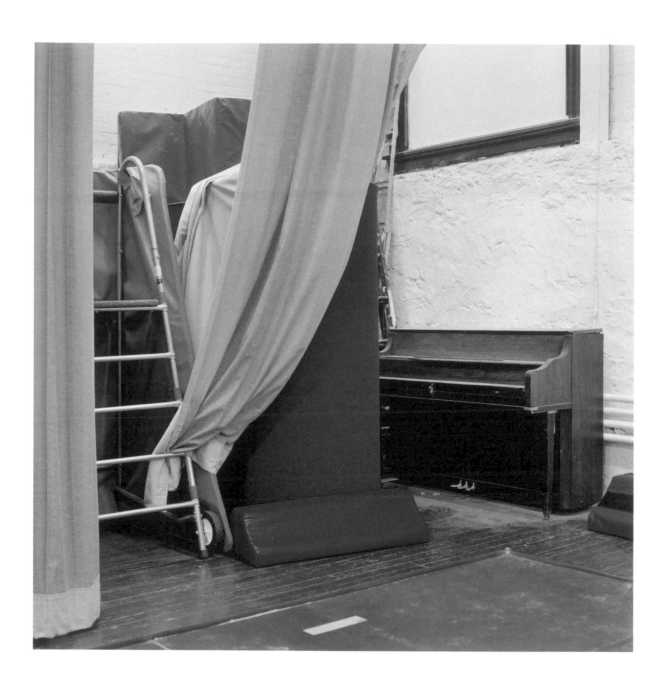

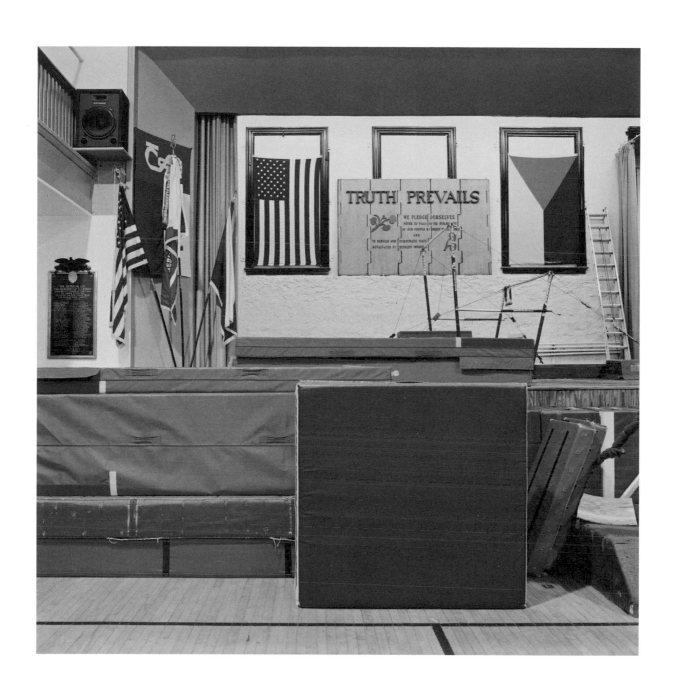

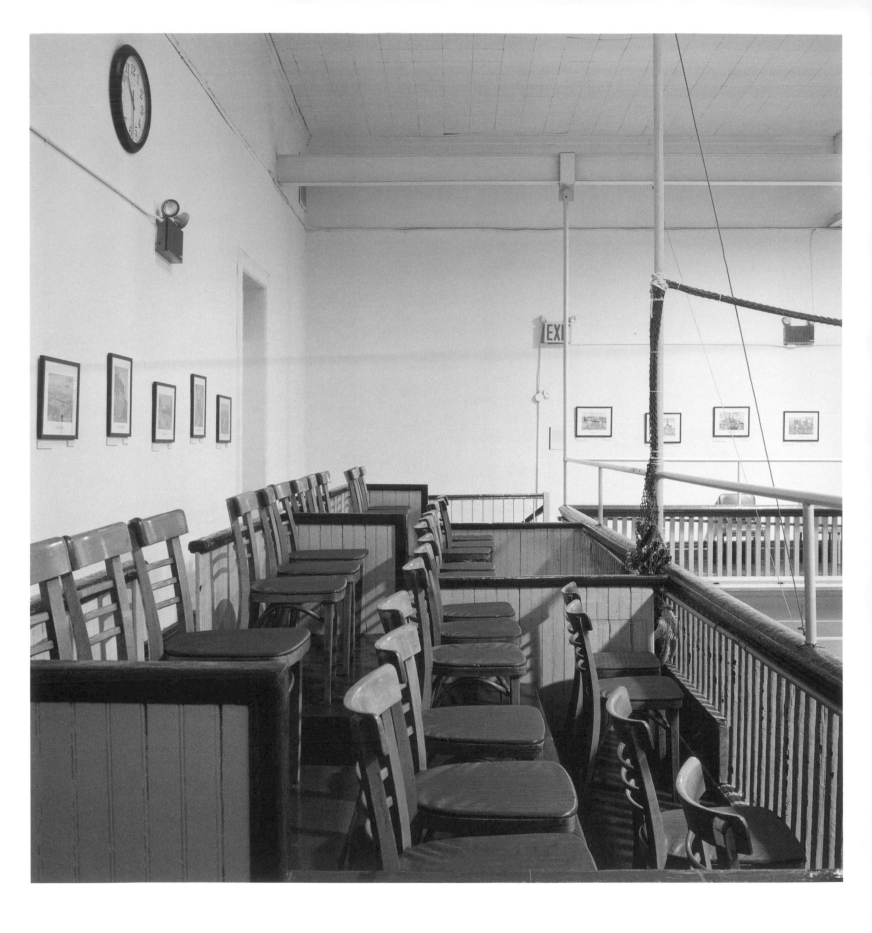

FIVE CLASSIC TRACKS
BY THE VELVET UNDERGROUND

"Sunday Morning" (1966)
"Heroin" (1967)
"I'm Waiting for the Man" (1967)
"Venus in Furs" (1967)
"Sweet Jane" (1970)

CBGB & OMFUG

THE BIRTHPLACE OF PUNK
Where the Ramones, Blondie, and Television
revolutionized rock 'n' roll

In 1973, club promoter Hilly Kristal founded CBGB, a live venue situated in a 4,000-square-foot space previously occupied by the Palace Bar. Its full name was CBGB & OMFUG, which stood for "Country, Bluegrass, Blues and Other Music For Uplifting Gormandizers." Located in the middle of the Bowery, a district then considered dangerous, the blues fans never showed up.

On March 31, 1974, while the club's finances were at their lowest, Kristal decided to book the band Television to play what was one of their first concerts. Not long after the gig, CBGB became a hub for the New York underground rock scene: the Ramones, Blondie, Patti Smith, Wayne County & the Electric Chairs, and Talking Heads all began their careers on its stage. The venue is remembered fondly for its dirtiness, its medieval toilets, the foul chili con carne it served and, of course, for its countercultural audience.

The undisputed mecca of punk in the mid-1970s, CBGB remained a benchmark for rock fans in the following decades. The club hosted several generations of mythical punk, hardcore, and indie bands, including Suicide, Sex Pistols, The Clash, Bad Brains, Sonic Youth, Beastie Boys, Prong, and Agnostic Front, later followed by rock bands such as The Strokes and The White Stripes.

CBGB closed its doors on October 15, 2006 after the building's owner, the Bowery Residents' Committee, decided not to renew the club's lease. Patti Smith gave the last performance there. The venue is now a shop, selling clothes by the designer John Varvatos; some elements from CBGB's later years have been kept intact, including posters and flyers covering the walls, a piece of the original stage, and amplifiers.

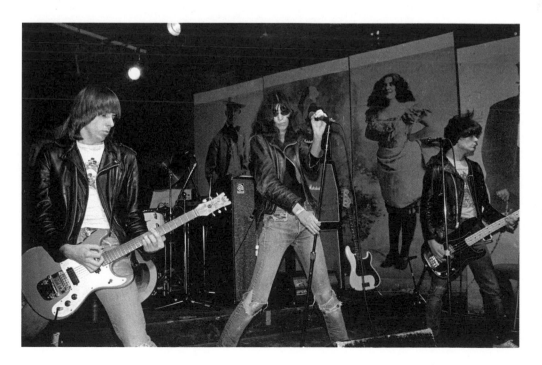

"One, two, three, four!" The Ramones live at CBGB, 1977.

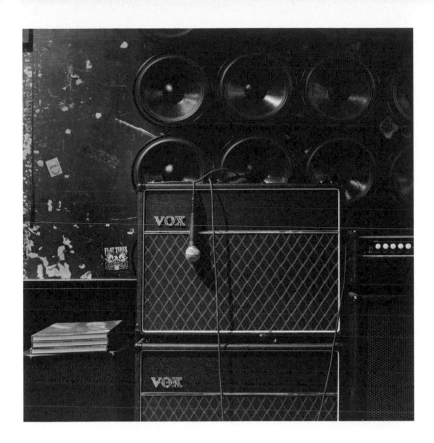

FIVE CBGB ANTHEMS

Ramones, "Judy is a Punk" (1976)
Blondie, "Rip Her to Shreds" (1977)
Johnny Thunders and the Heartbreakers, "Born to Lose" (1977)
Richard Hell and the Voidoids, "Blank Generation" (1977)
Talking Heads, "Life During Wartime" (1979)

A7

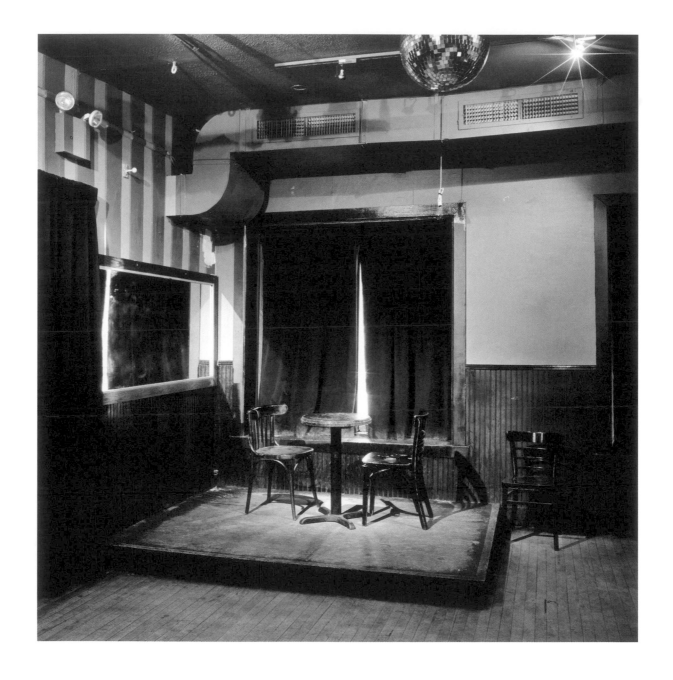

BRING THE NOISE
Where hardcore developed

Nestled in the middle of Alphabet City, an area then considered to be one of the most dangerous in Manhattan, A7 was the nerve center of the New York hardcore scene from 1981 to 1984. The Violators, Bad Brains, Agnostic Front, Antidote, Heart Attack, Urban Waste, The Abused, The Misguided, and even the Beastie Boys earned their reputation on the A7 stage long before CBGB (see p. 54) began to book artists like these. Managed by Doug Holland of the band Kraut and Jimmy Gestapo of Murphy's Law, with Raybeez from Warzone on the door, the club was a radical place that operated without a liquor license (which would earn the venue many police raids).

During its four years of operation, this narrow space was frequented by representatives of all the scenes that made up the East Coast rock spectrum. Those fans surely remember the times they spent locked inside A7 for entire nights: DIY to the core, there was only one key for the club's door, and it was frequently lost. The space on Avenue A operates today as Niagara, a neighborhood bar and nightlife spot.

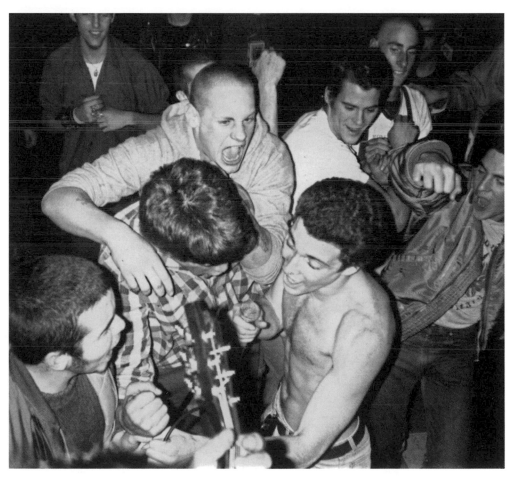

New York hardcore band The High and The Mighty performing at A7 (singer Drew Stone in front, third from left), 1983.

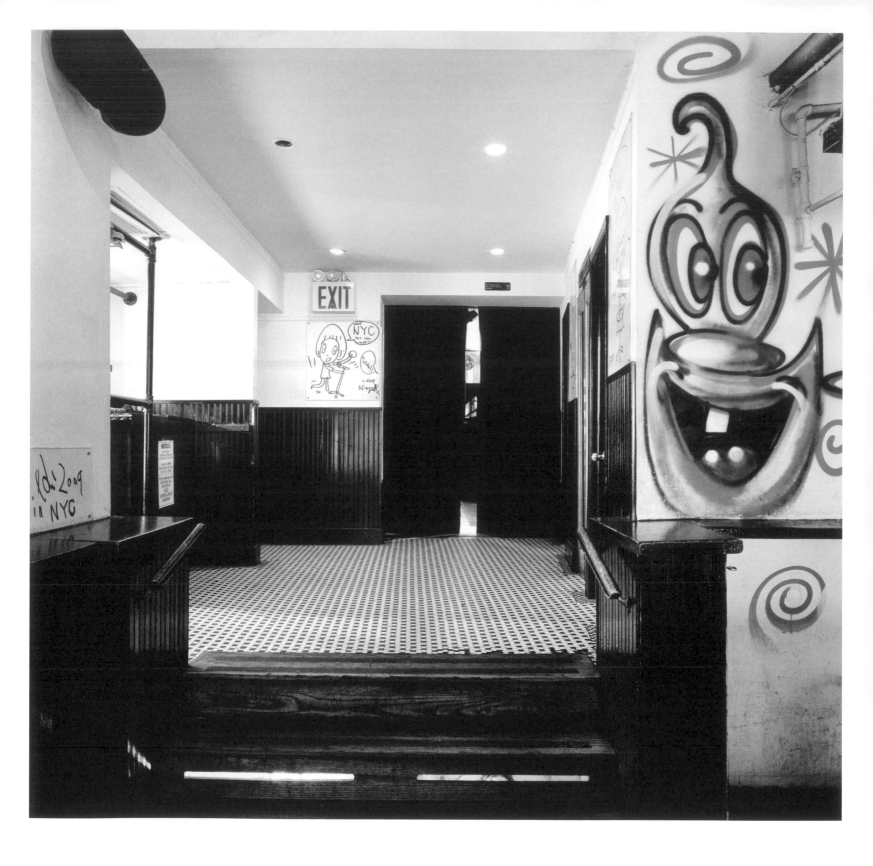

NEW YORK HARDCORE PLAYLIST

Bad Brains, "Attitude" (1982)
The Violators, "Summer of '81" (1982)
Antidote, "Life as One" (1983)
Agnostic Front, "Victim in Pain" (1984)
Murphy's Law, "Panty Raid" (1989)

CAFÉ SOCIETY

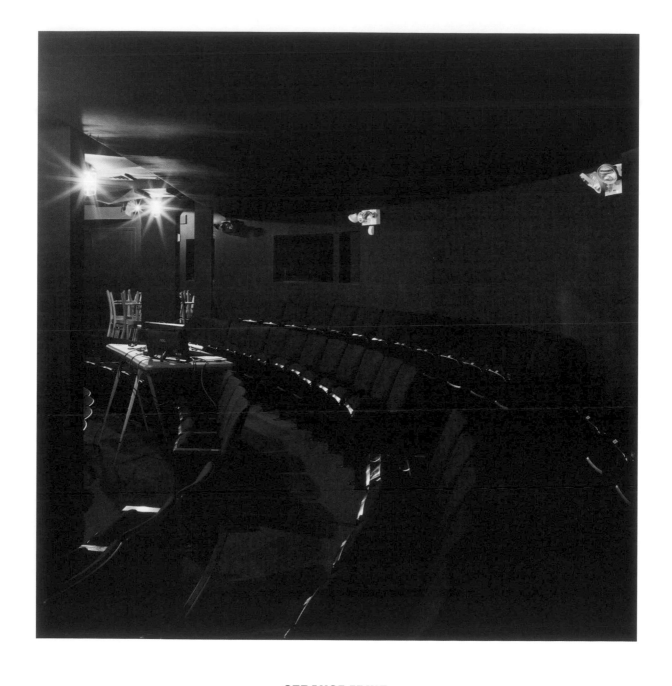

STRANGE FRUIT

The first non-segregated nightclub in America

Opened in 1938 in Greenwich Village, Café Society was founded by Barney Josephson, inspired by European political cabarets, to promote talented African American artists. As the first multi-racial club in the United States, Café Society was also a means for Josephson to shake the assumptions and habits of the typical rich clientele of New York nightclubs. Both black and white customers were treated equally and the walls were covered with satirical graffiti featuring the musings of musicians, patrons, and members of Josephson's team.

Promoted as "the wrong place for the right people" by Josephson, Café Society maintains a special place in American music history thanks to the famous artists who played there, including Lena Horne, Sarah Vaughan, Art Tatum, Big Joe Turner, and of course Billie Holiday, who in 1939 sang her jazz standard "Strange Fruit" at the club for the first time. She would end each of her concerts at Café Society with that song, leaving the scene with neither a word nor an encore. Recalling this later in life, Holiday said, "I opened Café Society as an unknown; I left two years later a star."

In 1947 Josephson's brother Leon was summoned by the House Committee on Un-American Activities under suspicion of Communist tendencies. After this episode, Café Society saw its business plummet, until it closed in 1948.

During the 1960s, 1 Sheridan Square housed the Haven, a gay club that was raided and closed down by the police for illegal activity. Shortly after, the Ridiculous Theatrical Company, directed by Charles Ludlam, champion of slapstick comedy, moved in. Ludlam's classics *Camille* and *The Mystery of Irma Vep* premiered there. Since 1998, the Axis Company theater has occupied the location.

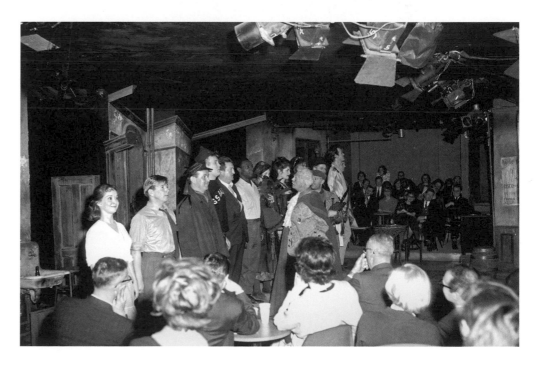

Overcome by the performance of the actors in his play *The Hostage*, Irish writer Brendan Behan (fifth from left) joins in the show, Café Society, 1962.

FIVE TIMELESS BILLIE HOLIDAY SONGS

"Fine and Mellow" (1939)
"Strange Fruit" (1939)
"Don't Explain" (1944)
"Good Morning Heartache" (1946)
"Lady Sings the Blues" (1956)

STUDIO RIVBEA

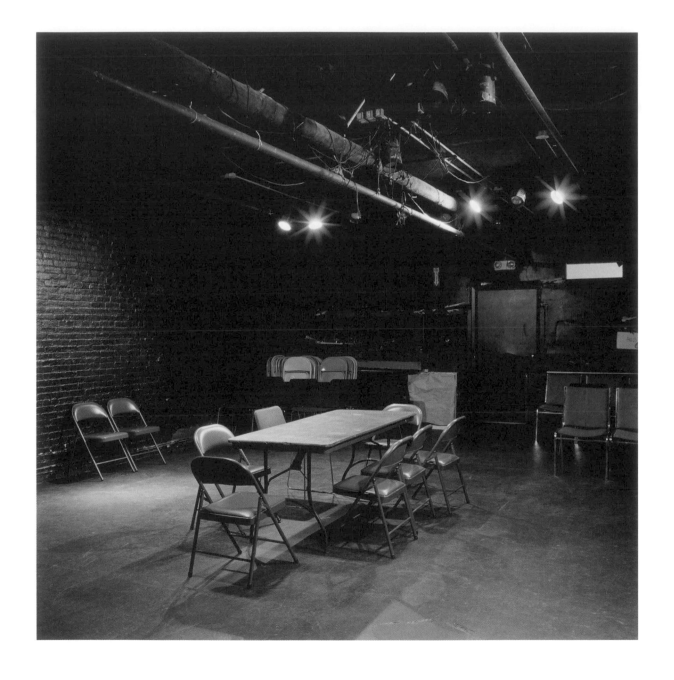

FOR INSIDERS ONLY

Legendary Manhattan jazz loft

In the late 1960s, avant-garde jazz was poorly received in NYC clubs. Many musicians, wishing to push their craft, could not find work or acceptance since they were in fierce competition with more traditional players. In 1969 American jazz musician and composer Sam Rivers, a former colleague of Miles Davis and Dizzy Gillespie, rented a loft with his wife Beatrice downtown in NoHo. There, he founded his own club in order to spearhead a new model for the development of jazz: musicians lived and worked in the same space, while the public was invited in to observe the evolution of their art. Studio Rivbea initiated the jazz loft era in Manhattan. According to writer Will Hermes, Rivers's studio was "ground zero for the loft scene."

Rivers performed at Studio Rivbea over the years with many of his bands (including The Sam Rivers Trio, The Sam Rivers Quartet, and The Rivbea Orchestra) and welcomed jazzmen such as Ahmed Abdullah, Anthony Braxton, Olu Dara, David Murray, and Wadada Leo Smith.

Since the late 1970s, 24 Bond Street has been the home of the Gene Frankel Theatre and Film Workshop. Its eponymous founder was an actor, theater director, and acting teacher who played a major part in the establishment of the Off-Broadway scene. He directed plays like *To Be Young, Gifted and Black* by Lorraine Hansberry in 1969, and the musicals *Lost in the Stars* in 1972 and Harry Chapin's *The Night That Made America Famous* in 1975.

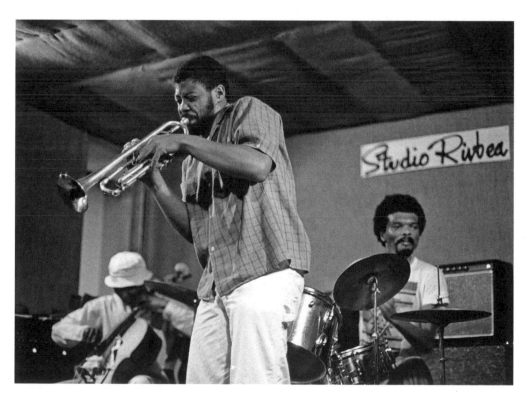

William Parker, Arthur Williams, and Rashid Bakr
at Studio Rivbea, July 1976.

FIVE ESSENTIAL SAM RIVERS ALBUMS

Fuchsia Swing Song (Blue Note Records, 1964)
Conference of the Birds, Dave Holland Quartet,
 with Sam Rivers, Anthony Braxton,
 and Barry Altschul (ECM, 1973)
Streams, Live at Montreux (Impulse!, 1973)
Sizzle (Impulse!, 1976)
Contrasts (ECM, 1980)

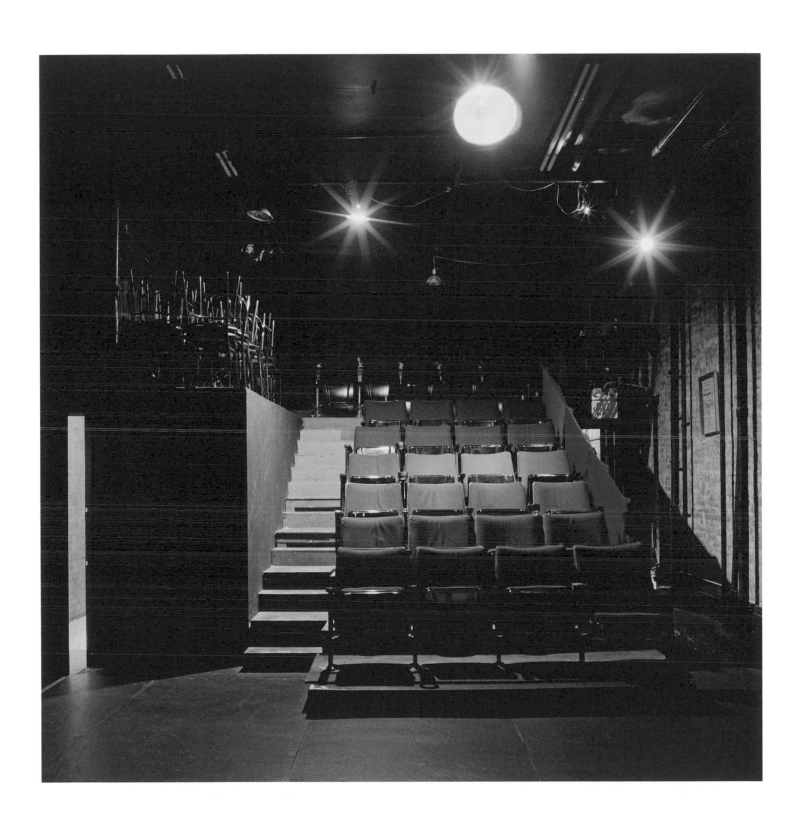

VILLAGE VANGUARD

JAZZ ISLAND

One of the world's oldest and most famous jazz clubs

The promoter Max Gordon opened the world-famous jazz club Village Vanguard in February 1935 in the heart of Greenwich Village. After hosting folk artists and Beat poets during its early years, the place became dedicated exclusively to jazz in 1957. The club consequently welcomed some of the greatest musicians of the genre, including Miles Davis, John Coltrane, Horace Silver, Charles Mingus, Thelonious Monk, Stan Getz, and Carmen McRae.

Determined to help launch the careers of young artists, Gordon recorded several concerts in his club and later released them as albums. The first to record a gig at the venue was saxophonist Sonny Rollins, on November 3, 1957. Several albums by Max Roach, Bill Evans, and Tommy Flanagan followed. Since Gordon's death in 1989, his wife Lorraine has run the club. It looks exactly the same today as it did during its early years.

Jazz legend Dizzy Gillespie plays at Village Vanguard, 1973.

FIVE ALBUMS RECORDED LIVE AT VILLAGE VANGUARD

Sonny Rollins, *A Night at the Village Vanguard* (Blue Note, 1957)
Bill Evans Trio, *Sunday at the Village Vanguard* (Riverside, 1961)
Junior Mance Trio, *At the Village Vanguard* (Jazzland, 1961)
John Coltrane, *Live at the Village Vanguard Again* (Impulse!, 1966)
Sun Ra Sextet, *At the Village Vanguard* (Rounder, 1993)

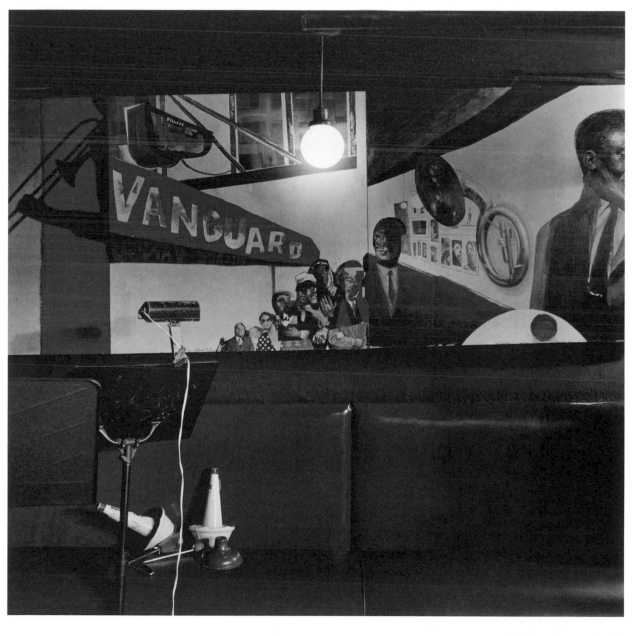

SOUNDSCAPE

UNIVERSE OF SOUNDS

First space dedicated to world music in NYC

Soundscape was the first venue dedicated to free improvisation and world music in New York. It was opened in fall 1979 by freelance producer Verna Gillis alongside history's most renowned free jazz artists and contemporary musicians, including Derek Bailey and Sun Ra. Until its closure in 1983, the club honored Latin jazz, Afro-Cuban music, and avant-garde improvisation with artists coming from all over the world to play there. Soundscape opened during a key period when most of the city's jazz lofts of the 1970s had shut down. It became an essential venue for progressive jazz players like Marion Brown, Robin Kenyatta, Steve Lacy, and Sunny Murray. While directing activities at the venue on West 52nd Street, Gillis also produced other larger events, such as King Sunny Adé's concert at Roseland Ballroom in 1983, the first known African pop concert in New York, referred to by the *New York Times* as "the pop event of the decade."

In 1984, Gillis took a turn in her career and started working with artists (including Youssou N'Dour, whom she managed for twelve years) on a one-to-one basis on career development. After Gillis closed the venue on West 52nd Street, she continued to produce concerts on a larger scale in spaces such as the Purple Barge on the Hudson River, La MaMa, SOB's, Symphony Space, and The Village Gate. Many of the shows performed at Soundscape were also recorded; later, Gillis donated her library—including 300 hours of Soundscape live recordings—to the permanent archives of Columbia University's radio station, WKCR. The station continues to broadcast these recordings and has made them available on the Internet. Today the space on West 52nd stands empty.

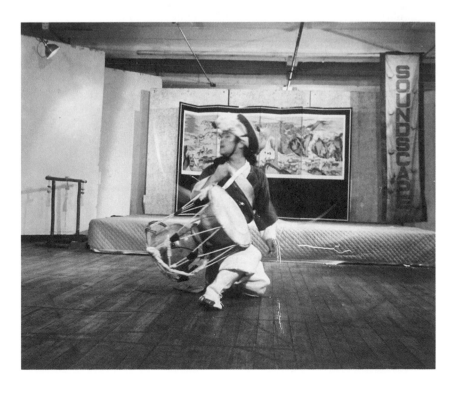

A performance by the South Korean percussion ensemble SamulNori at Soundscape, 1982.

FIVE ALBUMS RECORDED AND PRODUCED BY VERNA GILLIS

Rev. Audrey E. Bronson and Becky Carlton, Minister of Music, *Are You Ready for Christmas?* (Folkways, 1976)
Javanese Music from Surinam (Verna Gillis with David Moisés Perez Martinez, Lyrichord, 1977)
From Slavery to Freedom, the SARAMAKA MAROONS of Suriname (Lyrichord, 1981)
Merengues from the Dominican Republic (Lyrichord, 1981)
Traditional Women's Music from Ghana: Ewe, Fanti, Ashanti, and Dagomba (Folkways, 1981)

ART
VEI

"One can't paint New York
as it is, but rather as it is felt."

Georgia O'Keeffe

80 WOOSTER STREET

NEW FILM CULTURE
Pioneering independent cinema

In 1967 80 Wooster Street was a vacant industrial building, but that changed when George Maciunas acquired it that summer. It was the first artists' co-operative building that he organized in the dilapidated merchandise district that has since become known as SoHo. He envisioned that artists would move into the area through the communal purchase of these old warehouse buildings and he played an instrumental role in achieving this, setting up 28 such co-operatives before he died in 1978.

80 Wooster, though, was more than just an artists' loft—it became a downtown cultural center. Maciunas operated from its basement, the Fluxus movement had its headquarters there, and in 1967 Jonas Mekas based the Film-Makers' Cinematheque there and used the ground floor as its theater. Mekas had created the Cinematheque in 1964 in order to get around the censorship laws of the time, after his arrests for screening Jean Genet's *Un chant d'amour* and Jack Smith's *Flaming Creatures*. Prior to its Wooster Street home, it had held screenings at City Hall Cinema, where Stan Brakhage's *Songs* and Andy Warhol's *Empire* premiered, and the Astor Place Playhouse, where the seminal Expanded Cinema Festival took place; it then moved to 41st Street, where Warhol's *Chelsea Girls* was screened for the first time.

Besides its daily film screenings, the Cinematheque at 80 Wooster held festivals and happenings. Ornette Coleman, Terry Riley, and La Monte Young performed there, and it was where Philip Glass held his first New York concert, and Richard Foreman staged his first three plays. Today, the ground floor is the Christopher Fischer clothing store and an architect's office inhabits part of the basement.

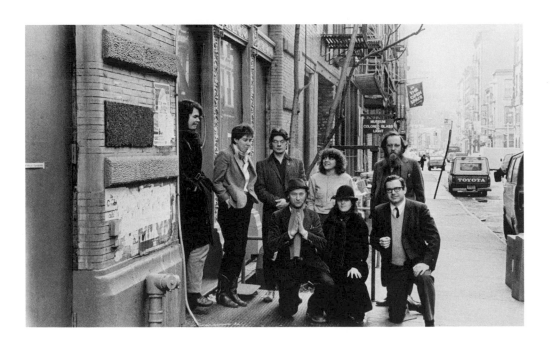

Anthology Film Archives staff outside 80 Wooster, 1980. (Top L–R) Rick Stanbury, Meredith Lund, Robert Harris, unidentified, P. Adams Sitney; (bottom L–R) Jonas Mekas, Susan Greene, Robert A. Haller.

FIVE PIVOTAL SOHO ART SPACES, 1960s–1970s

98 Greene Street: Space created by collectors Holly and Horace Solomon for emerging art, experimental theater and film, and poetry readings

112 Workshop / 112 Greene Street / White Columns: Founded in 1970 by artists Jeffrey Lew and Gordon Matta-Clark, this experimental platform dedicated to exhibiting lesser-known artists is the oldest alternative non-profit space in New York

A.I.R. Gallery, 97 Wooster Street: Non-profit space founded in 1972 by artists Barbara Zucker and Susan Williams to show the work of women artists

Artists Space, 155 Wooster Street: Founded in 1972 to provide an alternative to museums and the commercial gallery system, and to support emerging artists

FOOD, 127 Prince Street: Non-profit alternative space and legendary restaurant opened in October 1971 by Gordon Matta-Clark and Carol Goodden in collaboration with other artists. It presented the concept of gathering, cooking, and dining as performance; it closed in 1973

32 Second Avenue

ANTHOLOGY FILM ARCHIVES

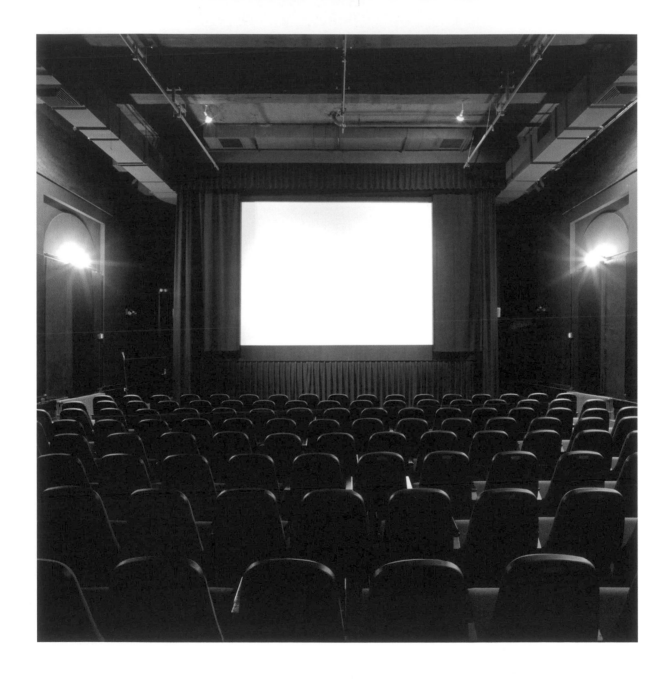

CINEMA AS LIFE
Home for independent and experimental cinema

Facing licensing problems with New York City at 80 Wooster, Jonas Mekas faded out the Film-Makers' Cinematheque and re-formed it into a completely new entity. Now called Anthology Film Archives, it opened at 425 Lafayette Street on November 30, 1970. Founded by Mekas along with film historian P. Adams Sitney, film-makers Peter Kubelka and Stan Brakhage, and film-maker/philanthropist Jerome Hill, Anthology Film Archives billed itself as "the first museum exclusively devoted to film as an art." The space became an international center for the preservation, study, and exhibition of film, with a particular focus on classic and avant-garde cinema. It was known for the Invisible Cinema theater (designed by Kubelka, this was a screening space where the viewer could see only the audience, not the screen) and its Essential Cinema Repertory (110 programs of classic films selected by the five creators of Anthology).

In 1974, Anthology was forced to move away from Lafayette Street and relocated to SoHo, in the former Cinematheque space. There, besides the Essential Cinema Repertory, it opened a video department, run by Shigeko Kubota and Nam June Paik. After acquiring an old courthouse building on the corner of Second Street and Second Avenue (its present home) in 1979, Anthology reopened in the fall of 1989. Since then, because of its primary dedication to the conservation and exhibition of avant-garde and independent film, it has become one of the most unique film archives in the world. It runs daily screenings in its two theaters, operates a large film preservation program, maintains an extensive paper archive (books, periodicals, documents), and houses a library. Its screenings are devoted exclusively to international and local independently produced cinema and classic film.

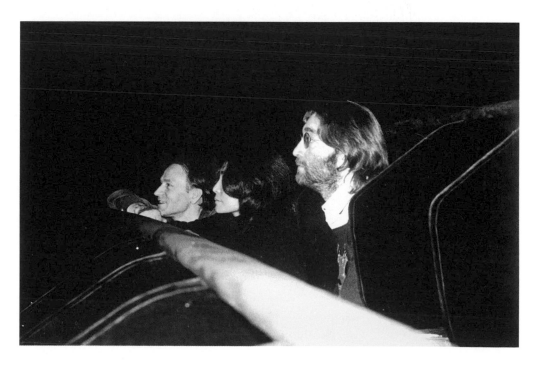

Jonas Mekas, Yoko Ono, and John Lennon, 1970.

FIVE FILMS BY PETER KUBELKA

Mosaik im Vertrauen (1954–5)
Adebar (1956–7)
Schwechater (1957–8)
Arnulf Rainer (1958–60)
Pause! (1977)

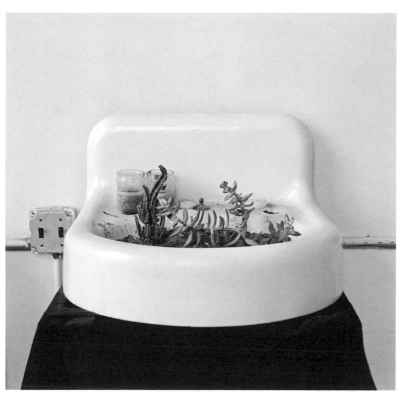

BRIDGE THEATER

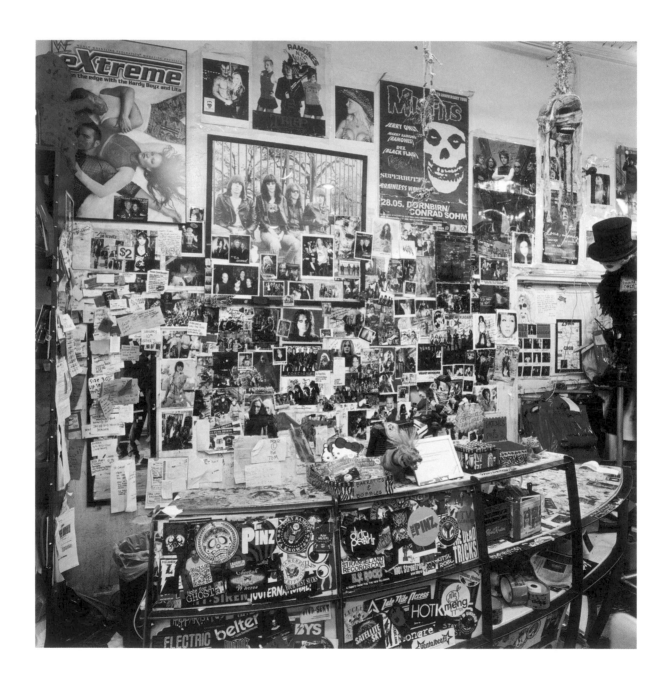

POETRY HAVEN

Mecca for avant-garde theater and performing arts

Like most of the buildings on St. Mark's Place, Hamilton-Holly House, located at number 4, has had many incarnations since its construction in 1831 by Thomas E. Davis. It was sold in 1833 to Colonel Alexander Hamilton, the son of Alexander Hamilton, the first US Secretary of the Treasury. After two additional floors and a large hall were built, the house became the property of the C. Meisel Company, a manufacturer of musical instruments, from 1901 to 1952. Between 1955 and 1967, it became successively the Tempo Playhouse, the Bridge Theater, and the New Bowery Theate, three venues known for programming experimental theater, music, dance, and independent film.

In 1963, the film-maker Jonas Mekas was arrested for obscenity for screening *Flaming Creatures*, a sexually explicit experimental film by Jack Smith, and for showing Jean Genet's (later disowned) 26-minute film *Un chant d'amour*, which included homosexual content, at the venue. That same year, Andy Warhol hosted the premiere of his film *Newsreels* there. At that time the space was known as the Bridge, and hosted frequent performances by Yoko Ono and John Cage.

In February 1964, the theater was used to showcase the New York Poets Theatre, a group founded in October 1961 by James Waring, LeRoi Jones (Amiri Baraka), Alan Marlowe, Fred Herko, and Diane di Prima that would only stage one-act plays by poets. From 1969 to '75, 4 St. Mark's Place became Limbo, a hippie clothing store—one of the first in New York—and then Trash and Vaudeville, a punk clothing store that boasted the Ramones among its regular customers. Trash and Vaudeville is still open today, and in 2004 the building was designated a New York City Landmark.

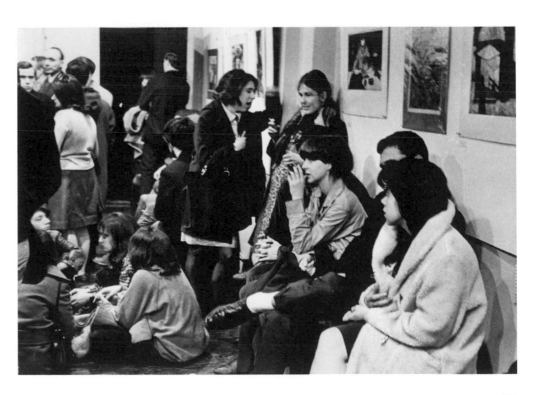

The audience of a concert by The Fugs at the Bridge Theater, November 2, 1965.

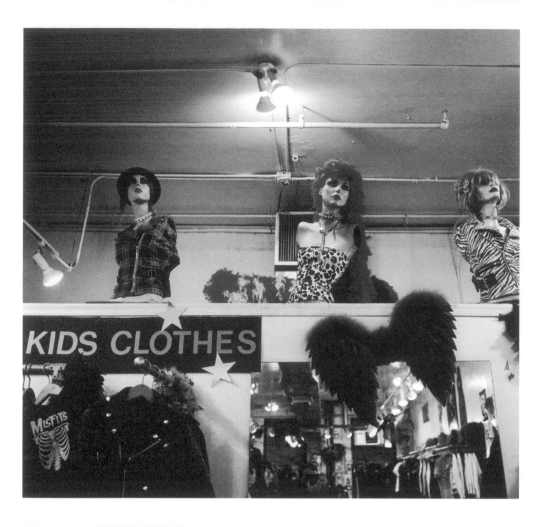

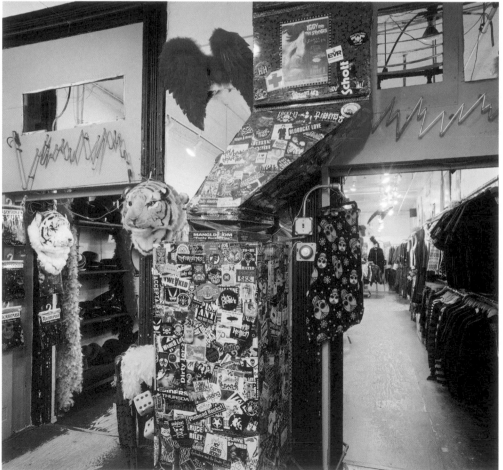

FIVE BOOKS BY DIANE DI PRIMA

This Kind of Bird Flies Backward (New York, 1957)
War Poems (New York, 1968)
Memoirs of a Beatnik (New York, 1969)
Loba, Parts 1–8 (New York, 1978)
Recollections of My Life as a Woman:
 The New York Years (New York, 2001)

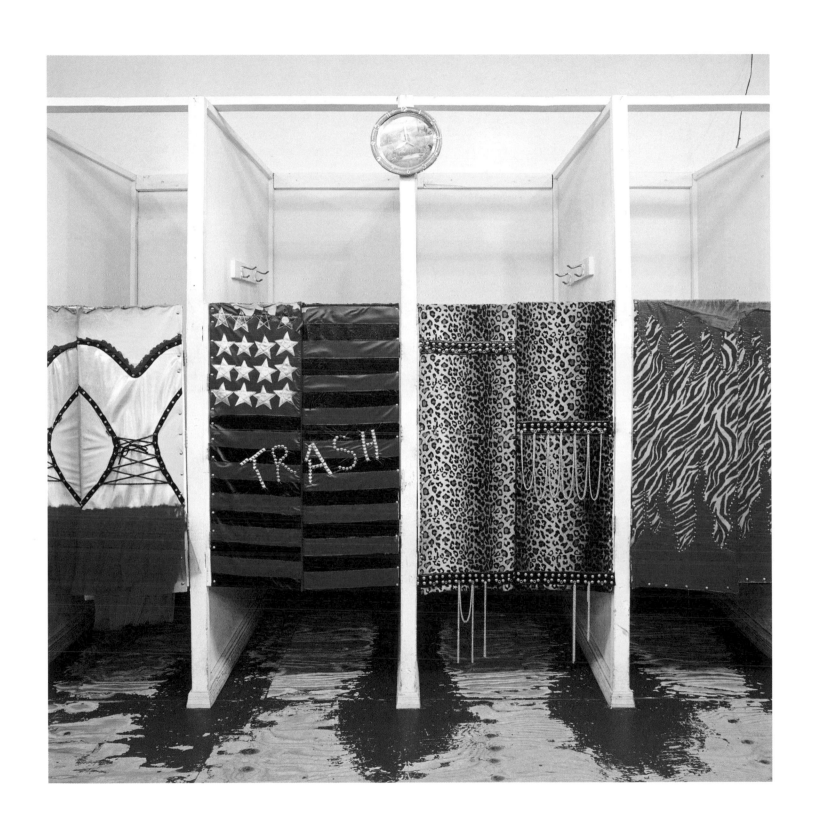

THE ALTERNATIVE MUSEUM

ALTERNATE STATE
Ahead of the times and behind the issues

Founded in 1975 by artists Geno Rodriguez, Janice Rooney, and Robert Browning, and originally known as The Alternative Center for International Arts, The Alternative Museum moved from its first address (28 East 4th Street) in 1979 to a 4,000-square-foot ground-floor space on White Street. This was a mere few blocks away from other important non-profit arts organizations, including the Center for New Art Activities (93 Grand Street), Collective for Living Cinema (52 White Street), and Franklin Furnace (112 Franklin Street).

Until its closure in 2000, The Alternative Museum (which had moved to 594 Broadway) hosted exhibitions, concerts, and performances that explored philosophical, social, and political issues. It also provided a voice to disenfranchised artists, becoming a complement to the larger established museums and a paradigm for newer artist-founded organizations (such as Art in General, and later Exit Art). In its 25-year history, The Alternative Museum presented more than 600 concerts, poetry readings, workshops, and panel discussions, and over 400 exhibitions, including "Disinformation: The Manufacture of Consent" (1985), which featured the works of Gregory Sholette, Alfredo Jaar, Martha Rosler, Leon Golub, and Nancy Spero; and "Artists of Conscience" (1991), which showcased, among others, Gran Fury, Hans Haacke, Luis Camnitzer, and David Hammons. Having closed its exhibition space The Alternative Museum now runs an online archive of selected projects at alternativemuseum.org, and 17 White Street is now a showroom that specializes in twentieth-century furniture and design.

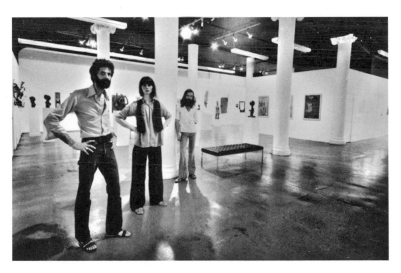

Alternative Museum founders Geno Rodriguez, Janice Rooney, and Robert Browning, 1975.

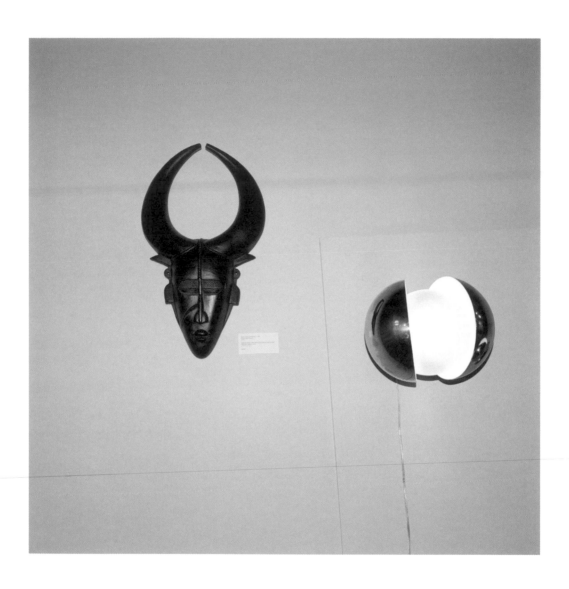

SIGNIFICANT EVENTS IN ALTERNATIVE ART HISTORY, NYC, 1970s–1980s

Artists Meeting for Cultural Change (group, founded 1975)
Printed Matter, Inc. (bookshop and publisher, founded 1976)
An Anti-Catalog (artists' book, The Catalogue Committee of Artists Meeting for Cultural Change, 1977)
Heresies (feminist magazine, founded 1977)
"Disinformation: The Manufacture of Consent" (exhibition, The Alternative Museum, New York, 1985)

ST. MARK'S CHURCH IN-THE-BOWERY

A WORKSHOP FOR WORDS
Home for modern poetry

First built as a family chapel in 1660 by Peter Stuyvesant, governor of New Amsterdam, St. Mark's became the property of the Episcopal Church in 1793. Soon after, Alexander Hamilton helped incorporate the church as the first Episcopal parish independent of Trinity Church in the United States. In 1919, the arts made their entrance into the church when the poet Khalil Gibran became a member of its board committee. In 1922, Isadora Duncan danced in the church, followed by Martha Graham in 1930. In 1926, St. Mark's welcomed poet William Carlos Williams for a reading during the St. Mark's Sunday Symposium. In 1964, director Ralph Cook founded the Genesis Theatre inside the church, where Sam Shepard presented his first plays, *Cowboys* and *The Rock Garden*.

Over the years, St. Mark's Church has hosted several arts programs, including its most famous, The Poetry Project, an important venue in the development of experimental poetry which still exists today and was founded by the poet and translator Paul Blackburn. In November 1971, Patti Smith gave a reading there accompanied by guitarist Lenny Kaye, which launched her rock 'n' roll career and marked the founding of the Patti Smith Group. St. Mark's is also the home of Danspace Project, an initiative that has introduced and supported the work of many dancers and choreographers at the start of their careers, including Douglas Dunn, Bill T. Jones, and John Kelly. In addition, 131 East 10th Street was the headquarters of Richard Foreman's Ontological-Hysteric Theater, one of the pioneering institutions of avant-garde theater.

Nicanor Parra and Allen Ginsberg in the parish hall at St. Mark's Church, 1987.

FIVE RICHARD FOREMAN PLAYS PERFORMED AT ST. MARK'S CHURCH IN-THE-BOWERY

The Mind King (1992)
My Head was a Sledgehammer (1994)
Permanent Brain Damage (1996)
Paradise Hotel (Hotel Fuck) (1998)
Zomboid! (Film/Performance Project #1) (2006)

JUST ABOVE MIDTOWN (JAM)

BODY AND SOUL
The forefront of contemporary dance

Until the early 1970s minority artists, whether African American, Latino, or Asian, had very little chance to show their work outside the circuit of community centers and cultural institutions run within their communities. Determined to open an alternative venue dedicated to the exhibition of African American abstract art and culture, documentary film-maker Linda Goode Bryant created the non-profit artist space Just Above Midtown (JAM) in 1974.

A former education director at the famous Studio Museum in Harlem, one of the first art venues in the US dedicated to African American artists and audiences, Bryant developed her ambitious program, which included exhibitions, performances, screenings of experimental films, seminars, and also published books (such as *Contextures*, 1978) and magazines.

JAM soon became a social space in which arts organizations— including the Black Rock Coalition, which promotes the creative freedom and work of black musicians—could take their first steps and where the public could observe the development of their work (for instance at the famous "Brunch with JAM" events). Among those who work or have worked with JAM are visual artists David Hammons and Fred Wilson, choreographer Bill T. Jones, performance and dance artists Lorraine O'Grady Gold and Ishmael Houston-Jones, and musicians Steve Coleman, Cassandra Wilson, and Butch Morris.

First set up on 57th Street in a neighborhood of art galleries, a rent increase forced JAM to relocate to 178 Franklin Street in Tribeca in 1980; it stayed there until 1984. The organization closed down in 1988. The space now houses the studio and apartment of Spanish painter Carlos Fragoso.

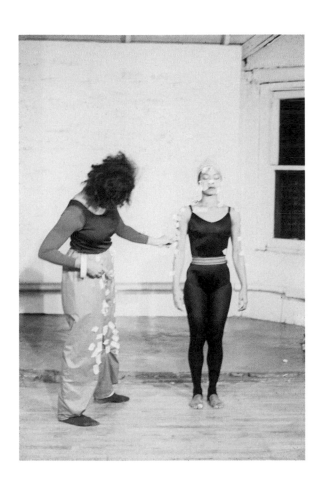

A performance featuring the artist Senga Nengudi and dancer and choreographer Cheryl Banks, created with jazz musician Butch Morris, at JAM, 1981.

FIVE DANCE PIECES BY BILL T. JONES

Intuitive Momentum (with Arnie Zane, 1983)
It Takes Two (1989)
Broken Wedding (1992)
Love Re-Defined (1996)
World II (18 Movements to Kurtag) (2002)

Intuitive Momentum (with Arnie Zane, 1983)

DIXON PLACE

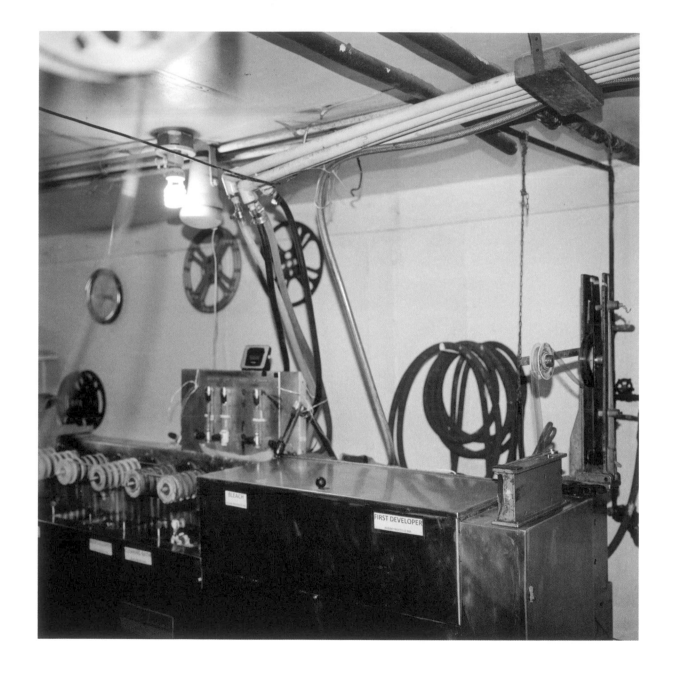

ART AT HOME
Underground literature and experimental performance

In 1986, Ellie Covan rented a storefront at 37 East 1st Street to recreate the salon-style events with writers and performing artists that she had discovered in Paris. Aware of the difficulty for emerging artists to find venues in which to test new ideas and techniques, Covan decided to create an intimate space where they could develop their work in front of a live audience. Artists such as Meredith Monk, John Leguizamo, Eve Ensler, and Lisa Kron have experimented and tested ideas at Dixon Place over the years, without the pressures of production costs and premature press exposure.

In addition to the 1st Street location, Dixon Place's other sites have included the living room of Covan's apartment at 258 Bowery (1992), the former Vineyard Theater on 26th Street (1999), and 161 Chrystie Street (2003), where Dixon Place continues to fuel the evolution of new art by people from the fields of music, theater, fine art, dance, and performance. Over the years, both Covan and Dixon Place have received several awards for their work, including a Bessie Award (New York Dance and Performance Award) for Covan's service to the community in 1989. In 1990 Dixon Place was awarded a *Village Voice* Obie for Off-Broadway theater and in 1999 it received City University of New York's Edwin Booth Award for Excellence in Theater.

37 East 1st Street is now the home of Pac Lab, an integral part of the East Village film community. For over 30 years, Pac Lab has developed and processed 8mm, Super 8, and Super 16 films by Martin Scorsese, Robert De Niro, Spike Lee, Patti Smith, and the Beastie Boys, to name a few.

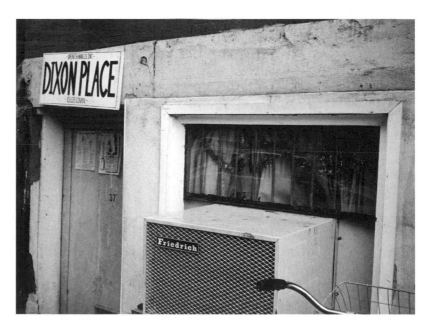

The entrance of Dixon Place, 1989.

FIVE CLASSIC MOVIES SET IN NEW YORK

Midnight Cowboy (dir. John Schlesinger, 1969)
Taxi Driver (dir. Martin Scorsese, 1976)
Manhattan (dir. Woody Allen, 1979)
The Warriors (dir. Walter Hill, 1979)
25th Hour (dir. Spike Lee, 2002)

THE KITCHEN

THE FUTURE IS NOW

Influential space for visual arts and experimental music

"When ... The Kitchen [was founded] there was no place doing what we were doing. Video artists needed a place to present their work. Anthology Film Archives was in existence then and doing wonderful things, but it was primarily concerned with film. Also, Millennium Film Workshop would present work by Michael Snow, Tony Conrad, etc., but it wasn't video. What we were doing at The Kitchen was really something new, something high tech in terms of hardware. And as far as I was concerned, composers coming from the downtown scene had no place to play other than informally in lofts."

Rhys Chatham, quoted in *Alternative Histories: New York Art Spaces, 1960 to 2010,* ed. Lauren Rosati and Mary Anne Staniszewski (Cambridge, MA, 2012)

Frustrated by the lack of video art in museums and galleries, artists Woody and Steina Vasulka rented out the kitchen of the Mercer Arts Center, located in the former Broadway Central Hotel in Greenwich Village, in June 1971. First conceived as an artist collective, The Kitchen developed into a non-profit space dedicated to video art and performance.

In 1973, The Kitchen moved to the second floor of 59 Wooster Street, at the corner of Wooster and Broome streets in the former LoGiudice Gallery building, where it began to host happenings, dance performances, and experimental music concerts in addition to its previous activities. Philip Glass, Eric Bogosian, Glenn Branca, Robert Longo, Rhys Chatham, Vito Acconci, Meredith Monk, Steve Reich, and Cindy Sherman were among the artists who performed here.

The Kitchen is still an internationally acclaimed arts institution widely known for its commitment to experimental work. Since 1986, the space has been located at 512 West 19th Street in Chelsea and provides instrumental support for the early and mid-career development of young artists. Today the Wooster Street space houses the long-established Brooke Alexander Gallery.

Talking Heads play The Kitchen, 1976.

NAUMAN

OLDENBURG RAUSCHENBERG

FIVE FILMS ABOUT PHILIP GLASS

Music with Roots in the Aether: Opera for Television (dir. Robert Ashley, 1976)
"Philip Glass," *Four American Composers* (dir. Peter Greenaway, 1983)
A Composer's Notes: Philip Glass and the Making of an Opera (dir. Michael Blackwood, 1985)
Einstein on the Beach: The Changing Image of Opera (dir. Mark Obenhaus, 1986)
Glass: A Portrait of Philip in Twelve Parts (dir. Scott Hicks, 2007)

JUDSON MEMORIAL CHURCH

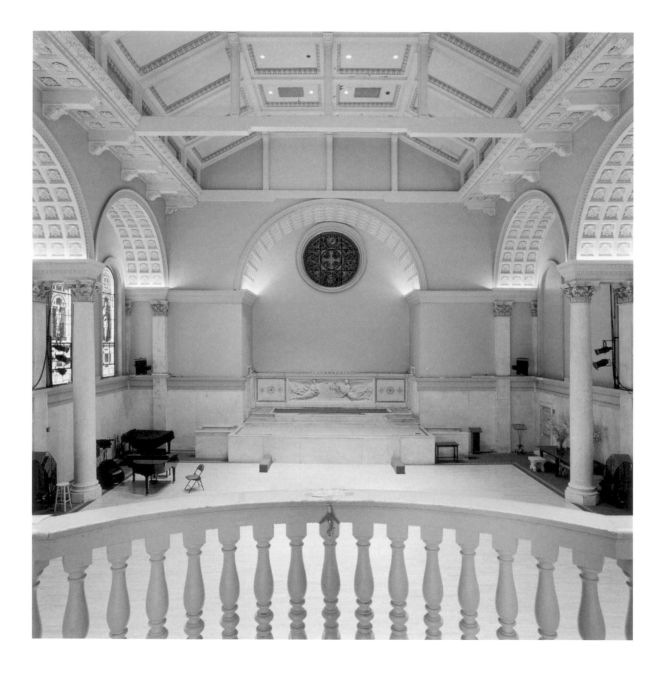

NO FEAR
Church of radical arts

Founded in 1890 by Reverend Edward Judson in memory of his father, and located on the south side of Washington Square Park, this church is known for and continues to assert its progressive agenda. Under the leadership of Reverend Howard Moody, Judson Church helped drug addicts during the 1950s, aided women seeking abortions in the 1960s, became a haven for runaway teens and prostitutes in trouble in the 1970s, and a refuge for AIDS patients in the 1980s.

Judson Church also played a significant role in the promotion of contemporary art in the mid-1950s. Reverend Robert Spike and his assistant Bernard Scott, convinced that religion and the arts share common spiritual values, opened the church's doors to a large number of innovative artists well before they became famous. Over the years, Allan Kaprow, Claes Oldenburg, Yoko Ono, and Jim Dine have been invited to show in the Judson Gallery, in the basement at the rear of the church. Between 1960 and 1962, after associate pastor Al Carmines formed the Judson Poets' Theater, the church hosted the Judson Dance Theater in its main sanctuary. This was founded by a group of contemporary dancers, choreographers, and artists, including Trisha Brown, Steve Paxton, Yvonne Rainer, Robert Dunn, Lucinda Childs, David Gordon, and Robert Rauschenberg, sometimes accompanied by minimalist composers Terry Riley, Philip Corner, and La Monte Young. Their work (as well as choreographic work by Merce Cunningham from the same period) laid the foundations of postmodern dance, the first avant-garde movement since the founding of modern dance in the 1930s and '40s.

During the second half of the 1960s, the Judson Gallery welcomed Nam June Paik, the Fluxus group, and members of the Auto-Destructive Art movement, and in the 1980s the gallery featured political performances and shows such as those created by Bread and Puppet Theatre. Since the 1980s, the general public has been able to track the progress of the avant-garde dance world through performances every Monday by the Movement Research collective. Judson Church is still very active in the presentation and promotion of the contemporary arts and providing aid to those in need.

Artist Carolee Schneemann's performance piece *Meat Joy* at the Judson Memorial Church, November 16, 1964.

"The Judson period was one of discovery for me. My first surprise was that we were in a church. My second surprise came later when we performed in the gym downstairs, and we soon became known for the use of alternative space."

Trisha Brown, quoted in *Remembering Judson House*, ed. Jerry Dickason and Elly Dickason (New York, 2000)

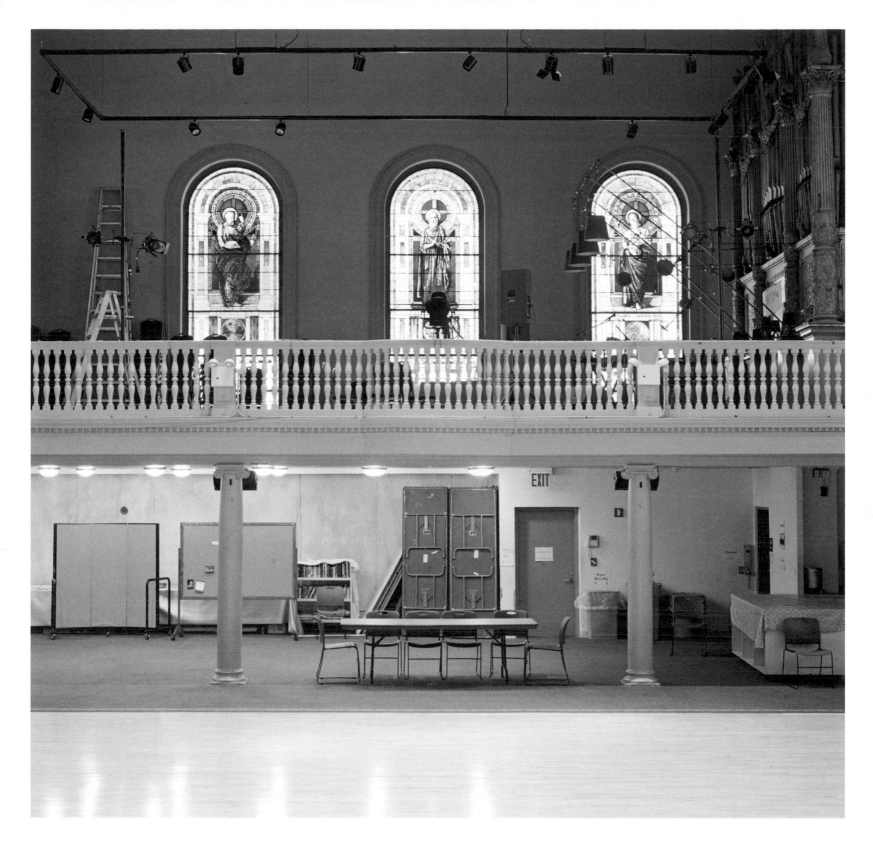

FIVE EVENTS AT JUDSON MEMORIAL CHURCH

Snapshots from the City (performance, Claes Oldenburg and Patty Mucha, 1960)
Pomegranada (Judson Poets' Theater, 1966)
"**12 Evenings of Manipulations**" (exhibition, 1967)
"**The People's Flag Show**" (exhibition, 1970)
Joan (Judson Poets' Theater, 1971)

THEATRE 80

HEART OF THE EAST
Timeless theater for pop, jazz, and drama

Founded during Prohibition, St. Mark's Theatre 80 was the heart of East Village cultural life for nearly 80 years. Called The Jazz Gallery during the 1950s, the theater was a popular destination for swing singers such as Frank Sinatra, avant-garde jazzmen (including Charles Mingus, Thelonious Monk, and John Coltrane), and Beat writers Jack Kerouac and Allen Ginsberg, who took up residence there. In the following decade, the theater—then called Pearl Theatre—promoted the careers of performers such as Billy Crystal and Gary Burghoff. It was one of the first cultural institutions to be part of the "Lower East Side movement," which worked against the abandonment and destruction of old buildings and promoted the rehabilitation of the area through the creation of cultural venues, making the East Village the artistic and countercultural center it became in the 1960s. Theatre 80 remains an important cultural platform and offers a diverse program centered on the performing arts, from traditional drama to experimental theater and contemporary dance.

St. Mark's Place at night, May 31, 1966.

FIVE LEGENDARY JAZZ TUNES PLAYED AT THEATRE 80

Thelonious Monk, "Blue Monk" (1954)
Harry "Sweets" Edison, "Willow Weep for Me" (1956)
John Coltrane, "Blue Train" (1957)
Charles Mingus, "Moanin'" (1958)
Art Blakey and the Jazz Messengers, "Ugetsu" (1963)

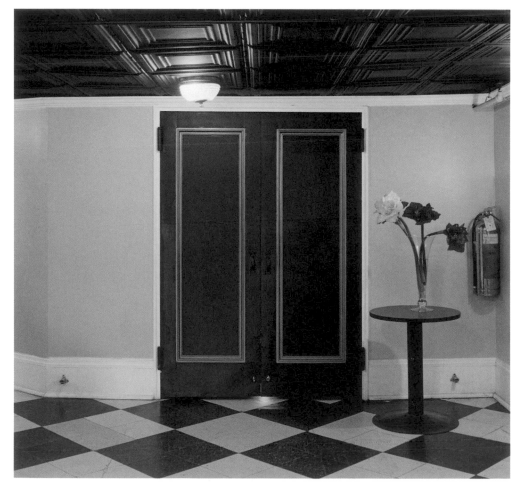

AG GALLERY

ANTI-GALLERY

First Fluxus gallery in Manhattan

"The anti-art forms are primarily directed against art as a profession, against the artificial separation of producer or performer ... They oppose forms artificial in themselves, models or methods of composition, of artificially constructed phenomena in the various areas of artistic practice, against intentional, conscious formalism and against the fixation of art on meaning, against the demand of music to be heard and that of plastic art to be seen; and finally against the thesis that both should be acknowledged and understood ... bird song is anti-art. The pouring rain, the chattering of an impatient audience, sneeze noises ... or compositions like 'letting a butterfly caught in a net fly away.'"

George Maciunas, launch of the Brochure Prospectus for the *Fluxus Yearboxes*, Wuppertal, West Germany, June 9, 1962

"Anti-art is life, is nature, is true reality—it is one and all."

George Maciunas, *Fluxus Manifesto* (1963)

In the late 1950s, young European artists inspired by Dada and influenced by the work of John Cage decided to reject all existing artistic categories and institutions—including the notion of the work of art itself. Fueled by Tristan Tzara's punk attitude and the irreverent irony of Marcel Duchamp, Fluxus—Latin for "current"—wanted to remove all borders between art and life. The group established its first headquarters in New York at 925 Madison Avenue. Under the auspices of Lithuanian-born artist George Maciunas, it exhibited abstract art, sold ancient musical instruments, and published its first manifesto, inaugurating an era of artistic happenings.

The gallery quickly expanded its ranks of young artists to include people such as Dick Higgins, Yoko Ono, and Jackson Mac Low. It also worked closely with minimal music composers John Cage and La Monte Young. The adventure at this location lasted only a few months, during which, every night, the gallery became what Maciunas called "a greenhouse for the germination of Fluxus." Debt-ridden, Maciunas had no other choice but to close AG Gallery before the end of 1961; he went to Wiesbaden, West Germany, where he worked for the US Army as a freelance designer. During this period he compiled the work of several Fluxus artists (La Monte Young, Ay-O, George Brecht, and Robert Watts) in what was to become the first anthology of the movement. *Fluxus 1* (1964), a conceptual art book, originally sold for $6, with a "Luxus Fluxus" edition costing $12 and containing "film, tape, objects and accessories." After closing AG Gallery, Maciunas later operated from 80 Wooster Street (see p. 80) and began working as the graphic designer for *Film Culture* magazine, which was edited by Jonas Mekas.

Operating as a cafeteria for several years, the gallery on Madison is now the reading room of the Eighth Church of Christ, Scientist.

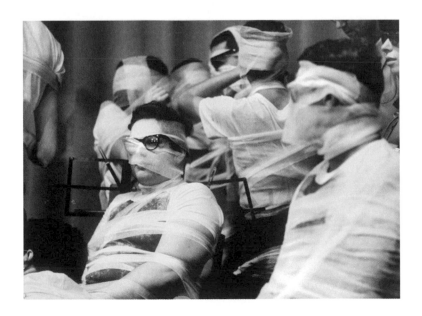

Bandaged orchestra during the Fluxus Festival, arranged by Yoko Ono at Carnegie Recital Hall, 1965.

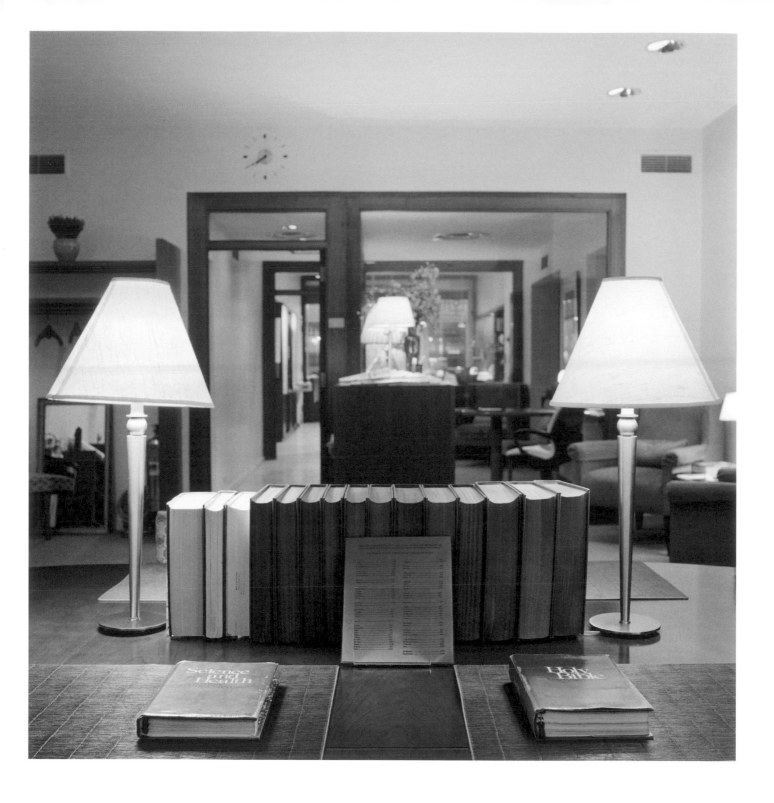

FIVE FLUXUS PIECES BY YOKO ONO

Cut Piece (1965)
Eye Blink (1966)
Four (Bottoms) (1966)
One (Match) (1966)
Two Virgins (1968)

LEO CASTELLI GALLERY

"ART IS MY BUSINESS"
Prominent art dealer's apartment and gallery

Leo Castelli bought his first work of art—a Matisse—in Vienna during his honeymoon. He and his wife, Ileana Sonnabend, founded their first gallery on Place Vendôme in Paris in 1939, specializing in Surrealist painting. When the war broke out, the couple left for the United States, where Castelli served with the American forces; he was awarded US citizenship at the end of the conflict.

In 1949, the Castellis were regulars at the Club, a private venue frequented by artists such as Willem de Kooning, Franz Kline, and Robert Rauschenberg. Castelli was entrusted with the sale of 100 Kandinsky paintings by the artist's widow, Nina, in the late 1940s, and in 1951 he curated the "Ninth Street Show," an exhibition considered a seminal event in the emergence of Abstract Expressionism. In 1957, he opened what was to become one of the world's most prominent art galleries in his own apartment. The next year, the gallery gave Jasper Johns his first exhibition.

Because of his discerning taste and self-assuredness, Castelli secured collaborations with some of the best artists of the time, using a system then unknown in the United States: he paid a monthly salary to the artists, whether he sold their works or not. Within ten years, the gallery became the international epicenter for Pop, minimal, and conceptual art, showing Johns, Rauschenberg, Cy Twombly, Roy Lichtenstein, Andy Warhol, Frank Stella, and Robert Morris, among others.

After his death on August 21, 1999, the Leo Castelli Gallery continued to operate at 18 East 77th Street in New York under the leadership of his widow, the art historian Barbara Bertozzi Castelli; number 4 is now occupied by Michael Werner Gallery.

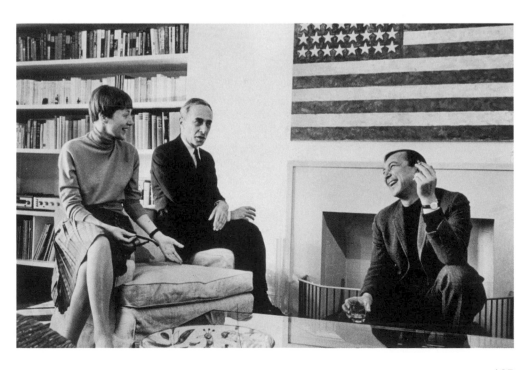

The artist Jasper Johns (right) with Leo Castelli and his wife in their home, April 21, 1966; in the background is one of Johns's flag paintings.

FIVE ICONIC EXHIBITIONS AT LEO CASTELLI GALLERY

First exhibition, February 1957: Willem de Kooning, Robert Delaunay, Jean Dubuffet, Alberto Giacometti, Marsden Hartley, Fernand Léger, Piet Mondrian, Francia Picabia, Jackson Pollock, David Smith, Theo van Doesburg

First Jasper Johns exhibition, January–February 1958

"Summary 1959–1960," May–June 1960: Norman Bluhm, Lee Bontecou, Nassos Daphnis, Edward Higgins, Jasper Johns, Gabriel Kohn, Bernard Langlais, Robert Rauschenberg, Ludwig Sander, Salvatore Scarpitta, Frank Stella, Cy Twombly, Jack Tworkov

"Andy Warhol: Wallpaper and Clouds," April 1966

"Tenth Anniversary Exhibition," February 1967: Richard Artschwager, Lee Bontecou, John Chamberlain, Nassos Daphnis, Edward Higgins, Jasper Johns, Donald Judd, Roy Lichtenstein, Robert Morris, Larry Poons, Robert Rauschenberg, James Rosenquist, Salvatore Scarpitta, Frank Stella, Cy Twombly, Andy Warhol

STU

"I love New York, even though it isn't mine, the way something has to be, a tree or a street or a house, something, anyway, that belongs to me because I belong to it."

Holly Golightly in Truman Capote, *Breakfast at Tiffany's*

PRIVATE

DIOS
AND
SPACES

JEAN-MICHEL BASQUIAT'S STUDIO

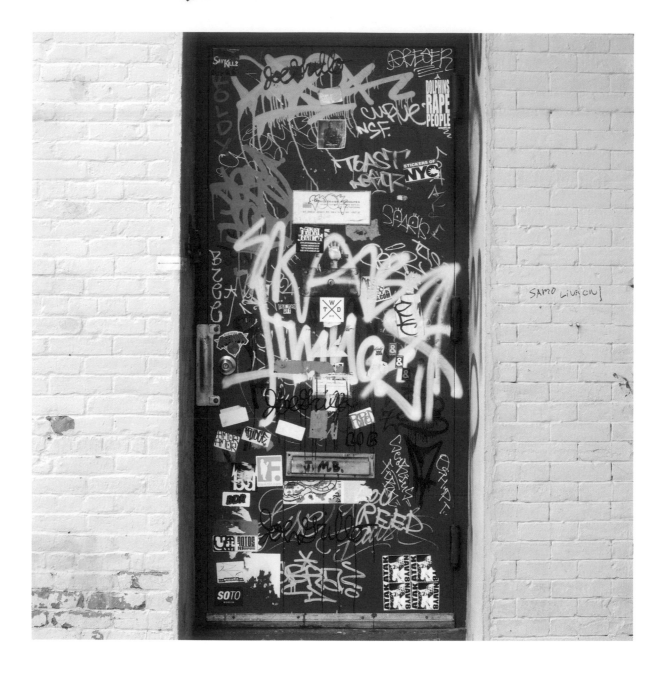

SAMO'S SANCTUARY

The last loft and studio occupied by the painter

"Jean-Michel was destined to be famous. Which is funny, because the whole story of *Downtown 81* is that he's nothing and he becomes rich in one day. It's like a magical story because It's really the story of his life in a way. He was really active ... he never stopped working. That's why he produced so much art: because he was always drawing. These drawings you see—he came over one night, I was working on my typewriter. He said, 'Just give me some paper!' He did that in few hours. He didn't stop!"

Glenn O'Brien, writer, former editor of Andy Warhol's *Interview* magazine, and screenwriter of *Downtown 81* (1981), interview with David Brun-Lambert

In 1985, while collaborating with Andy Warhol, the painter Jean-Michel Basquiat rented a two-story loft at the edge of the Bowery in a building Warhol owned. To Basquiat, 57 Great Jones Street was a strategic address. His friend Glenn O'Brien, then editor of *Interview* magazine and host of the television show *TV Party*, lived a few blocks away. Basquiat used to go to O'Brien's apartment to work, and would leave his drawings there when finished. Across the street was the restaurant Jones, where the artist often ate (it is still there today); once, he even left a book full of drawings as a tip for a waitress. Last but not least, the Bowery was also the best spot for him to buy drugs.

Basquiat lived in this space for three years until his death on August 12, 1988. The famous artworks he created there include the diptych *Eroica I*, which was presented at his last exhibition in New York in 1988.

Warhol died the year before Basquiat, and Warhol's heirs sold the building shortly after Basquiat's death. The apartment was divided into separate lots. A premium butcher's shop and a high-class restaurant now occupy the ground floor. The first floor has housed offices for two decades; these currently include a Japanese architect's practice. There are still a few traces of the many dangers—junkies, drug dealers, criminals—that contributed to the bad reputation of the Bowery in the 1970s and '80s. However, the neighborhood is now mainly crowded with cafés, designer shops, and restaurants.

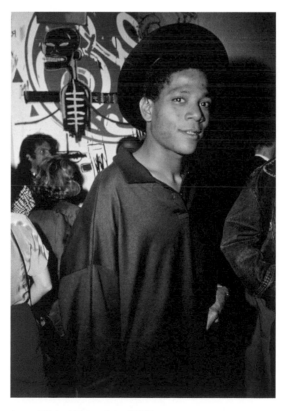

Jean-Michel Basquiat, 1985.

**FIVE TRACKS COMPOSED, PLAYED,
OR PRODUCED BY JEAN-MICHEL BASQUIAT**

Coati Mundi, "Palabras con Ritmo" (1981)
Gray, "Drum Mode" (1981)
Gray, "So Far So Real" (1981)
Rammellzee and K-Rob, "Beat Bop" (1983)
Gray, "Suicide Hotline" (2010)

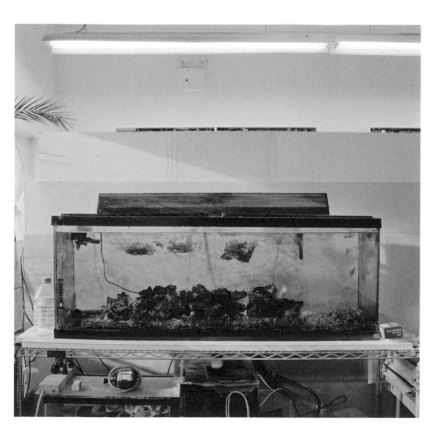

WILLIAM S. BURROUGHS / THE BUNKER

THE SHELTER
Home of the iconic Beat writer

In 1884, 222 Bowery housed the Young Men's Institute, the first New York branch of the YMCA. It was then home to a succession of beer gardens and saloons, and was surrounded by tenements and lodging houses. The artist Fernand Léger lived in the building from 1940 to '41; in the mid-1950s, Mark Rothko set up his studio in the building's old gymnasium and remained there until 1961.

In 1974, William S. Burroughs was awarded a contract to teach creative writing at City College of New York. With the help of the poet John Giorno, who had lived at 222 Bowery since the mid-1960s, Burroughs moved into the basement. His rent was $400 a month, and he called it "The Bunker." It was in this large space, consisting of a roomy lounge, kitchen, and bedroom, that Burroughs wrote his trilogy of novels *Cities of the Red Night* (1981), *The Place of Dead Roads* (1983), and *The Western Lands* (1987). In addition, he welcomed his admirers as guests, including Patti Smith, Keith Haring, Lou Reed, Susan Sontag, and Andy Warhol.

In 1981, Burroughs moved to Lawrence, Kansas, but would spend several weeks a year in The Bunker until his death in 1997. In 1998, Giorno managed to obtain National Historic Landmark designation for the building. In The Bunker, he installed a shrine to hold meetings and Buddhist meditation sessions. The space has changed very little since the Burroughs's death, and his bedroom and personal items are carefully preserved there.

William S. Burroughs in his Bunker, 1979.

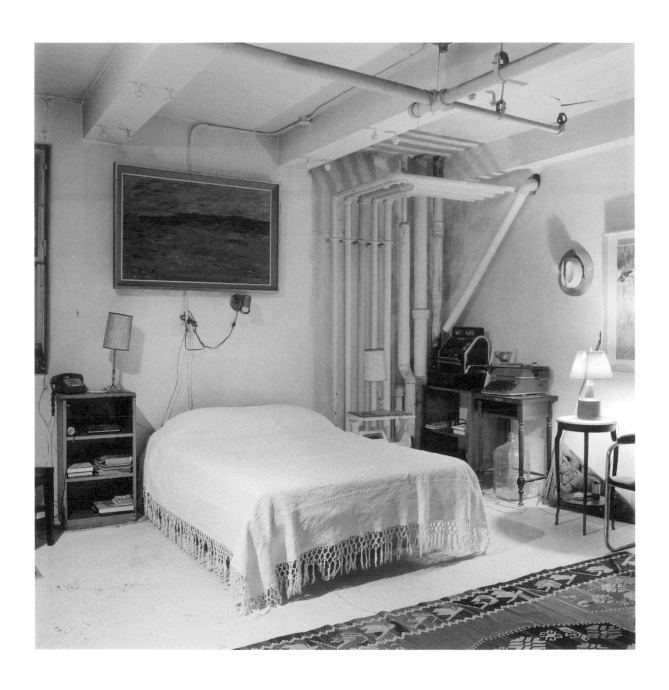

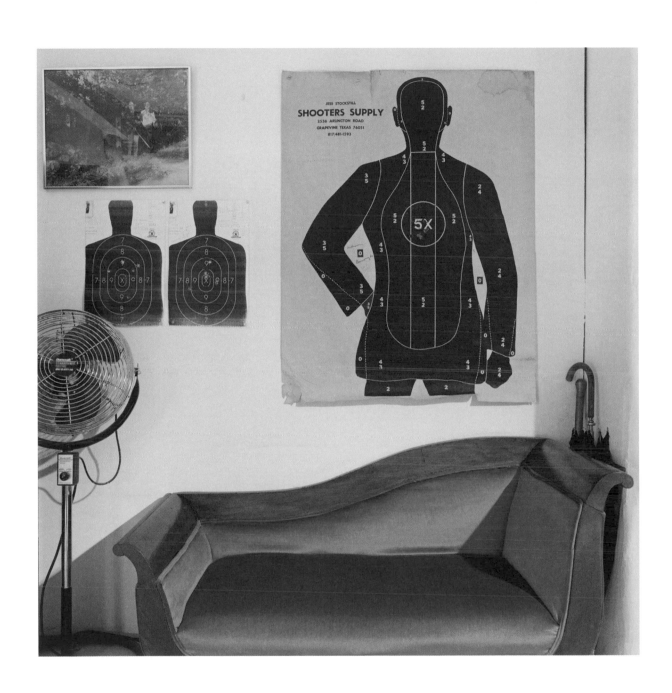

FIVE ALBUMS AND SONGS BY WILLIAM S. BURROUGHS

Call Me Burroughs (spoken word album, 1965)
You're the Guy I Want to Share My Money With (with John Giorno and Laurie Anderson, album, 1981)
Dead City Radio (album, 1990)
"The 'Priest' They Called Him" (with Kurt Cobain, single, 1993)
Spare Ass Annie and Other Tales (with The Disposable Heroes of Hiphoprisy, spoken word album, 1993)

MERCE CUNNINGHAM DANCE COMPANY STUDIO

ABOUT TIME
Studio of leading twentieth-century choreographer

"You have to love dancing to stick to it. It gives you nothing back, no manuscripts to store away, no paintings to show on walls and maybe hang in museums, no poems to be printed and sold, nothing but that single fleeting moment when you feel Alive."

Merce Cunningham, *Changes / Notes on Choreography* (New York, 1968)

"Dance is an art in space and time. The object of the dancer is to obliterate that."

Merce Cunningham, "Space, Time and Dance," *Trans/formation*, I/3 (1952)

The Westbeth Building hosted one of the largest communities of artists in the world. It had previously served as the headquarters of Bell Telephone Laboratories. After being converted between 1968 and 1970, it became a non-profit housing and commercial complex dedicated to providing affordable living and working spaces for artists and arts organizations. It housed a number of major cultural organizations, including The New School for Drama, the LAByrinth Theater Company, and the Brecht Forum. The low-cost studios, renovated by architect Richard Meier, housed artists including the photographer Diane Arbus, actor Moses Gunn, musician Gil Evans, and painter Robert De Niro, Sr.

For four decades, the top floor was home to the Merce Cunningham Dance Company. Here, the company continued the work pioneered in the 1950s by Cunningham at Black Mountain College in North Carolina. Using choreography and chance to promote a particular way of thinking and a personal world view, Cunningham revolutionized dance, decreeing that all points in space have the same value. In his pieces, there is no longer a soloist and a choir: instead, every dancer becomes a soloist.

The piano on which John Cage—Cunningham's partner and long-time collaborator—would sometimes play is still in the main rehearsal room at Westbeth. During rehearsals, Cunningham generally did not use music. The dancers often trained to the rhythms and sounds of New York, only discovering the music composed by Cage at a show's premiere.

Since Cunningham's death on July 26, 2009, the two rehearsal spaces seem as though they are inhabited by the ghosts of those who worked there: Jasper Johns, Charles Atlas, and others. The space is now the home of the Martha Graham Center of Contemporary Dance.

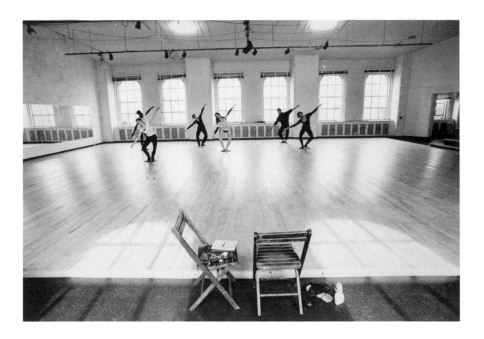

Rehearsal at Merce Cunningham Dance Company Studio, mid-1980s.

FIVE DANCE PIECES CREATED BY MERCE CUNNINGHAM AT WESTBETH

Second Hand (music by John Cage, 1970)
Squaregame (music by Takehisa Kosugi, 1976)
Roaratorio (music by John Cage, 1983)
Pond Way (set painting by Roy Lichtenstein, music by Brian Eno, 1998)
Interscape (set and costumes by Robert Rauschenberg, 2000)

ANDY WARHOL'S HOUSE

AN ART GIANT'S PRIVATE RESIDENCE

New York home of the "Pope of Pop"

Before his career as a fine artist started with an exhibition at the Bodley Gallery in 1956, Andy Warhol was a costume designer for a theater company and had also been distinguished for his illustration work in advertising. This background enabled him to become the most influential figure of Pop art, the art movement that emerged in the mid-1950s in Britain and in the late '50s in the US. In 1959 Warhol purchased his first building: a 16 ½-foot-wide, five-story 1889 Renaissance Revival row house which he shared with his mother, Julia Warhola (she lived in the basement), 25 cats (whose descendants can be seen everywhere in the neighborhood today), and innumerable pieces of furniture and trinkets.

On the ground floor, Warhol created a workshop, where he began to employ new techniques in his art with the help of a light projector, tracing and painting enlarged cartoon scenes from comic books onto canvas. He then applied this method to subjects ranging from photographs to Campbell's soup packaging to his dollar bill paintings.

In 1962, after the death of Marilyn Monroe, Warhol created his famous portraits of the star, followed by paintings of Elizabeth Taylor in 1963. Later on he systematized this process to develop a veritable catalogue of American popular culture. The Lexington Avenue ground floor was too small for Warhol to work on larger canvases, so the artist looked for a more spacious place and found the Hook & Ladder Company 13 (159 East 87th Street), a disused firehouse that was the property of the city's real estate department. It was around the same time that the artist got more and more interested in cinema and frequented Jonas Mekas's Film-Makers' Cooperative. When his mother died in 1972, Warhol moved to a larger townhouse on East 66th Street; the 1342 Lexington townhouse is still a private residence today, done up to luxury standards.

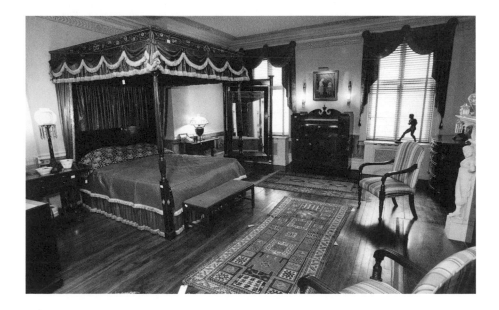

Andy Warhol's bedroom, 1988.

FIVE ARTWORKS CREATED BY
WARHOL AT 1342 LEXINGTON AVENUE

80 Two-Dollar Bills, Front and Rear (1962)
129 Die in Jet (Plane Crash) (1962)
Campbell's Soup Cans (1962)
Green Coca-Cola Bottles (1962)
Marilyn Diptych (1962)

THE FACTORY III

SUPERSTUDIO

The final Factory

In 1974, The Factory II left the sixth floor of the Decker Building
at 33 Union Square to invest in the third floor of a building that formerly
housed S & H Green Stamps. While Warhol was mainly involved in
experimental film projects at the second Factory, at 860 Broadway he
would go back to painting, a discipline he had abandoned for a decade.

Some of the first artworks he created there were his *Time
Capsule* pieces, a series of standard packing boxes that he had
salvaged during the move from Union Square and filled every month
with the hundreds of objects that cluttered his office. In the third
Factory, Warhol also began to create numerous screen-printed
paintings: the *Skull* series, the *Hammer and Sickle* series, and
Shadows, to name a few. Among the works he conceived there, the
"society portraits" remain the most iconic. Made with a Polaroid camera,
they presented portraits of celebrities that Warhol photographed and
then developed on canvases sized 40 by 40 inches.

While *Interview* magazine continued to be published out of the
third Factory, Warhol ended his collaboration with Paul Morrissey
and started working on a show entitled *Andy Warhol's TV* with producers
Vincent Fremont and Michael Netter. In 1984, as The Factory was
about to close its doors, Warhol moved his video-related activities to
a studio on Madison Avenue and dedicated himself almost exclusively
to painting. He began new collaborations with Francesco Clemente,
Keith Haring, and especially Jean-Michel Basquiat, with whom he
mounted an exhibition in September 1985. The show was such a critical
failure that it led to a quarrel between the two painters, and Warhol
quit painting for good. Today 860 Broadway is occupied by the Joester
Loria Group, a licensing agency dedicated to building brands.

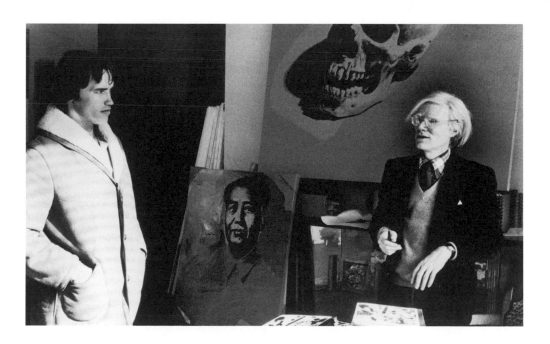

Arnold Schwarzenegger meets Andy Warhol at the third
Factory, 860 Broadway, January 14, 1977.

149

FIVE PAINTINGS BY ANDY WARHOL AND JEAN-MICHEL BASQUIAT

Brown Spots (1984)
General Electric with Waiter (1984)
Olympics (1984)
Bananas (1985)
Ten Punching Bags (Last Supper) (1985–6)

GIORNO POETRY SYSTEMS

A WELL-KEPT SECRET

Apartment and studio of an underground poet

John Giorno is a celebrated American poet and has supported the development of New York's underground scene since the early 1960s. Celebrated as the star of *Sleep*, Warhol's first film, he then befriended Robert Rauschenberg and Jasper Johns, with whom he collaborated. In the mid-1960s, he invited his friend William S. Burroughs back to New York to rent the basement at 222 Bowery, a space that would become "The Bunker" (see p. 134). Giorno still lives in the building today.

Inquisitive, adventurous, and a tireless experimenter, Giorno was passionate about the cut-up techniques invented by the artist Brion Gysin—an experimental process in which a text (or a sound) is cut up and rearranged to create something new. Giorno used this process on his own, and also with Burroughs, to make a series of audio recordings. Also inspired by the Experiments in Art and Technology organization's events in 1967, with which Rauschenberg and many other prominent artists were involved, Giorno developed a series of psychedelic poetry happenings in St. Mark's Church (see p. 96), with the help of electronic music pioneer Robert Moog.

In 1965 he founded Giorno Poetry Systems, a non-profit film production company, music group, and record label whose mission was to bring poetry to a new audience. In 1968, fascinated with the possibilities offered by technology, he launched a free poetry telephone service called Dial-A-Poem. By dialing a phone number, members of the public could listen to recordings of works by Giorno Poetry Systems artists, such as William S. Burroughs, Patti Smith, Laurie Anderson, Philip Glass, and Robert Mapplethorpe.

In the 1970s and '80s Giorno gave poetry readings and performances around the world, which included collaborations with Sonic Youth, Suicide, Throbbing Gristle, and Glenn Branca. Today he is still experimenting with poetry and visual art in his two studios at 222 Bowery. Over the course of his career he has released more than 55 LPs, dozens of performance videos, and published hundreds of poems.

John Giorno in 1969 during the first year of his Dial-A-Poem project.

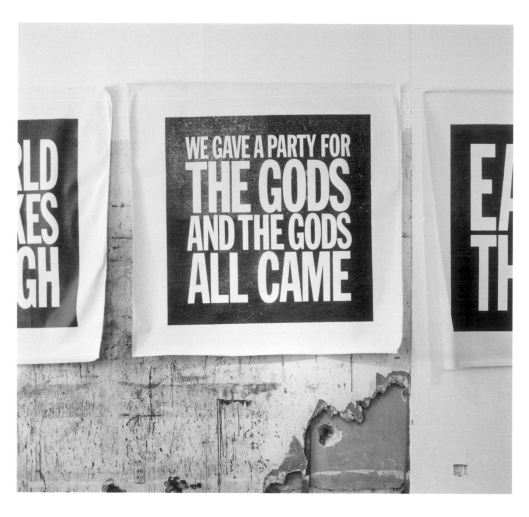

FIVE BOOKS AND RECORDINGS BY JOHN GIORNO

*Cancer in my Left Ball: Poems,
 1970–1972* (book, 1973)
You're the Guy I Want to Share My Money With
 (album, with William S. Burroughs
 and Laurie Anderson, 1981)
Grasping at Emptiness (book,
 by Richard Bosman, 1985)
*You Got to Burn to Shine: New and Selected
 Writings* (book, 1993)
*Subduing Demons in America: Selected Poems,
 1962–2007* (book, 2008)

ON THE

TOWN

MARIPOL'S SALON

PRIVATE NO WAVE LOFT
Apartment frequented by 1980s underground scenesters

"Over the years, the loft became a French-style 'salon'. Many creative people met there. Dozens of collaborations were born there."

Maripol, interview with David Brun-Lambert

A French woman raised in Morocco, Maripol settled in New York in 1976 with Italian photographer Edo Bertoglio. Within a few months, she became a fixture on the underground scene. Approached by a headhunter for the Italian label Fiorucci, Maripol became its art director, and by the mid-1980s had achieved some success with her own shop, Maripolitan, in NoHo. She also created her personal jewelry collection, which was worn by Grace Jones, Debbie Harry, and most famously Madonna, including on the cover of her 1983 *Madonna* album.

A Polaroid addict, she also took portraits of everyone who made New York underground life interesting in the 1980s, including Keith Haring, Fab 5 Freddy, Klaus Nomi, Jean-Paul Goude, and Glenn O'Brien, who introduced her to Jean-Michel Basquiat. When Elio Fiorucci signed on to finance a film about the underground art scene, Basquiat became the hero of *Downtown 81,* a movie written by O'Brien, directed by Bertoglio, and produced by Maripol.

Located in the heart of SoHo, Maripol's loft is still full of memories of 1980s New York, an era when her apartment doubled as a "salon" regularly attended by downtown figures such as curator Diego Cortez, musician John Lurie, rocker Lou Reed, and Pop idol Andy Warhol.

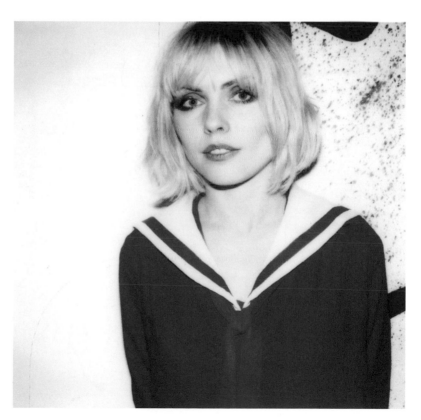

Debbie Harry at Maripol's loft, 1981.

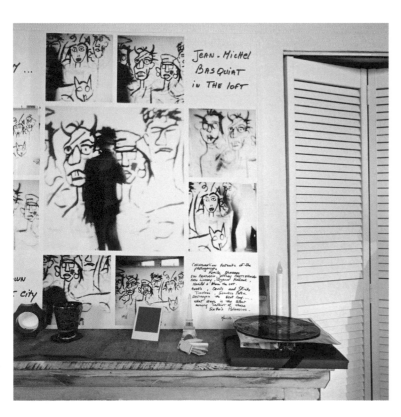

**FIVE TRACKS FROM THE
"DOWNTOWN 81" SOUNDTRACK**

Teenage Jesus and the Jerks, "Baby Doll" (1979)
Kid Creole and The Coconuts, "Mr Softee" (1980)
Suicide, "Mister Ray" (1980)
DNA, "Blonde Redhead" (1981)
Liquid Liquid, "Cavern" (1983)

KEITH HARING'S POP SHOP

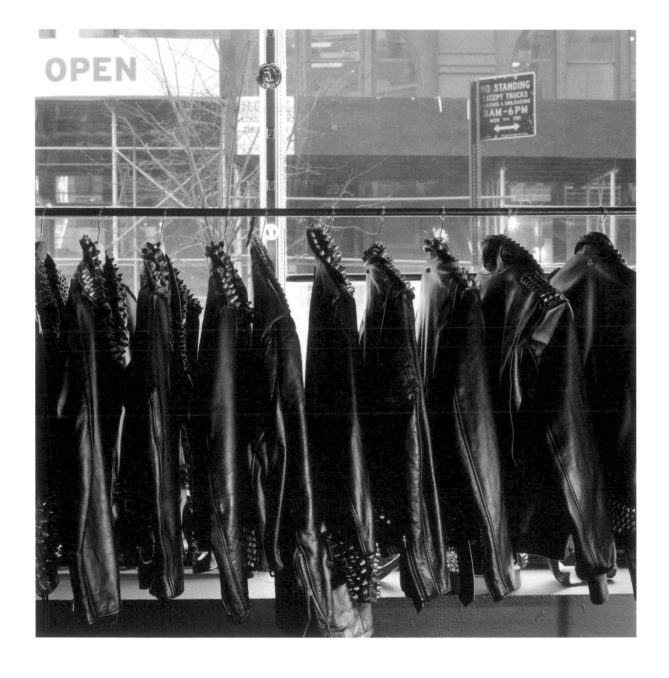

THE "POP" STORE

A vibrant boutique

In 1986, after gaining his reputation by drawing his unique cartoonish characters in Subway stations and on sidewalks, artist Keith Haring opened the Pop Shop in a small storefront on Lafayette Street. Here he sold T-shirts, posters, toys, and buttons printed with his now-iconic boldly drawn human figures. The shop had a clubhouse atmosphere and was dedicated entirely to Haring's work, including being painted with an enormous mural that covered the floor, walls and ceiling. Two years later, Haring launched another concept store in Tokyo, in a space made of two shipping containers welded together to form a single large room. The shop was soon closed, however, due to the large number of fake Harings that began to circulate on the Japanese market. The New York Pop Shop finally closed its doors to the public in 2005, fifteen years after Haring's death on February 16, 1990. Until early 2015 another boutique, Bess, known for its vintage, punk, and DIY clothing and accessories, occupied 292 Lafayette.

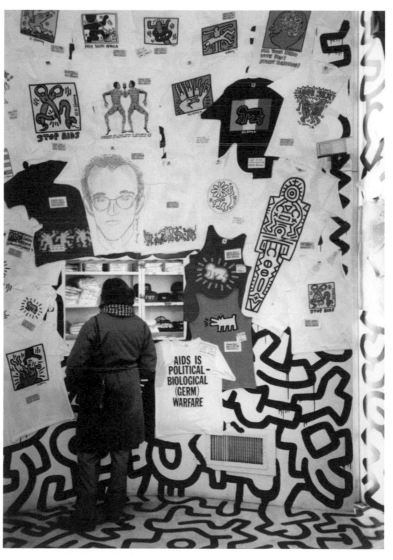

A customer looks at a T-shirt display in artist Keith Haring's Pop Shop, 1980s.

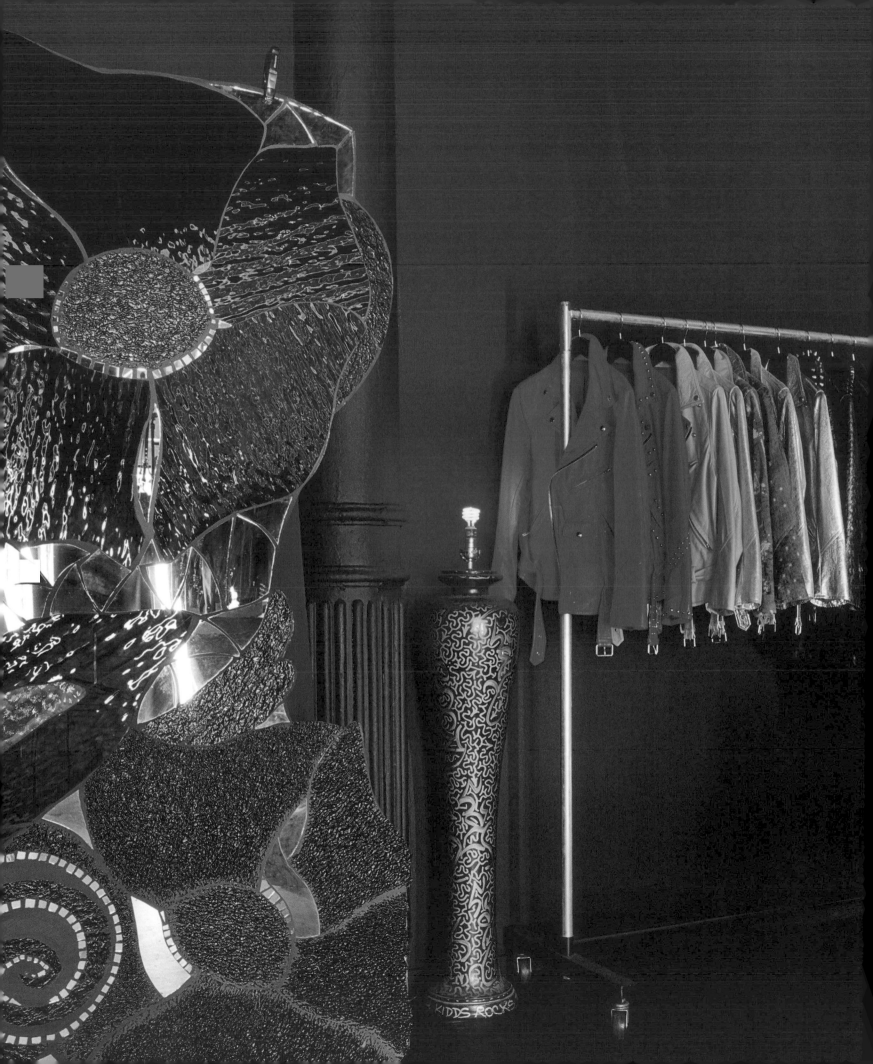

FIVE DESIGNS BY KEITH HARING

Poster for anti-nuclear rally, New York, June 12, 1982
Logo for New York City Department of Sanitation "Don't Be a Litter Pig" campaign, 1984
First day cover and limited-edition lithograph to accompany the United Nations stamp issue commemorating 1985 as International Youth Year
Poster and public service announcement for literacy campaign sponsored by New York Public Library Associations and Fox Channel 5, 1988
First day cover and limited edition lithograph to accompany the United Nations stamp issue commemorating 1990 as Fight AIDS Worldwide Year

CAFÉ BOHEMIA

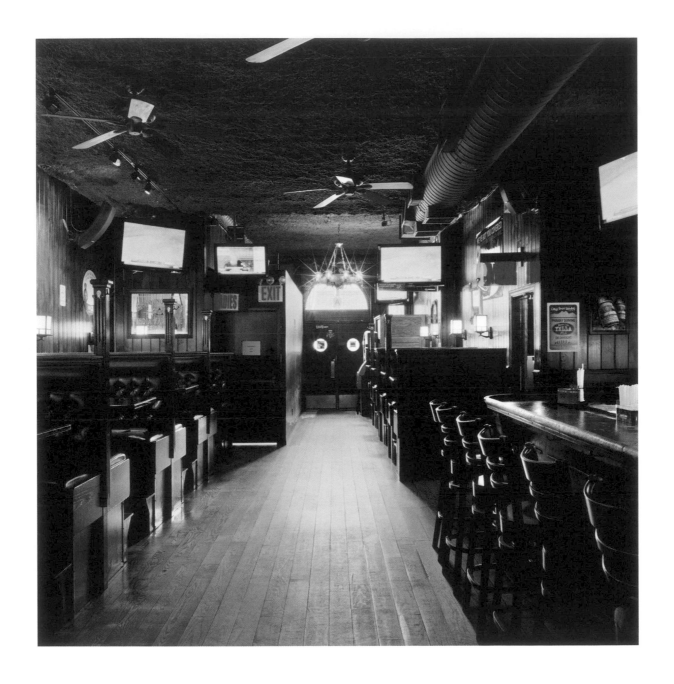

'ROUND ABOUT MIDNIGHT
Where jazz greats played and Beat writers listened

Opened by Jimmy Garofalo in 1949, Café Bohemia was first a restaurant and bar before becoming a progressive jazz club in 1955. Charlie Parker (then dealing with serious drug problems), who was sharing a room just across the street with the poet Ted Joans, convinced Garofalo to let him play there for several nights. As soon as the news went public, Café Bohemia established itself as the city's hottest new jazz club. Unfortunately, Parker died shortly before starting this series of concerts, but Kenny Dorham, Art Blakey, and Miles Davis soon came to play there. Marvin Koner took the cover photo for Davis's album *'Round About Midnight* at the Café in 1961.

It was also at Café Bohemia that saxophonist Cannonball Adderley made his debut, on June 19, 1955. Having just arrived in New York, he headed there with his brother Julian to listen to Oscar Pettiford's band. Since the saxophonist, Jerome Richardson, was absent that evening, Pettiford asked Charlie Rouse in the audience if he wanted to come up and play, but he didn't have his instrument with him. Pettiford noticed that Adderley was carrying a sax case, and asked him if he could lend his instrument to Rouse, but instead Cannonball suggested that he himself could go onstage and play with the band. Two nights later, he would give his very first official performance at Café Bohemia. On June 28 he recorded his debut album with Pettiford, and on July 14 he recorded his first album as a leader. Two years later, Cannonball Adderley joined the Miles Davis sextet. Café Bohemia is now the Barrow Street Ale House.

John Coltrane and Miles Davis playing at Café Bohemia, 1958.

FIVE JAZZ TUNES PLAYED AT CAFÉ BOHEMIA

Miles Davis, "Round Midnight"
Kenny Dorham, "Autumn in New York"
Art Blakey and the Jazz Messengers, "Moanin'"
Cannonball Adderley, "Autumn Leaves"
Oscar Pettiford, "Blues in the Closet"

MARSHALL CHESS CLUB

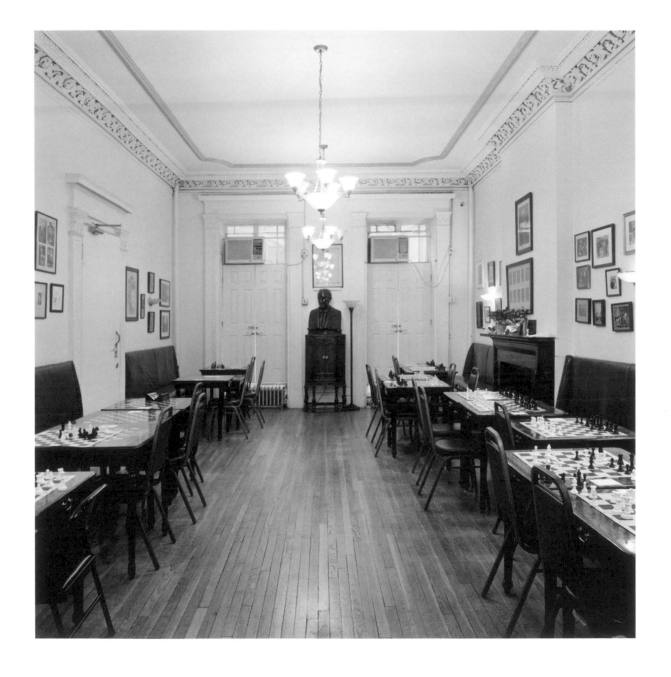

CHESS MECCA
Marcel Duchamp's and Bobby Fischer's chess club

Founded by chess champion Frank J. Marshall in 1915 and established in a beautiful two-story building on West 10th Street in 1931, Marshall is one of the oldest chess clubs in the United States. The members of this prestigious club have included Stanley Kubrick, James Sherwin, and Howard Stern, and grandmasters including Reuben Fine, Edmar Mednis, and the legendary Bobby Fischer. It was here in 1956 that Fischer played and won the "game of the century" when—at only thirteen years old—he defeated Donald Byrne in the Rosenwald Memorial tournament. Nine years later, Fischer participated in the Capablanca Memorial tournament held in Havana, Cuba, via telex from the Marshall Chess Club. The table on which he played this game is still there today.

Marcel Duchamp was another illustrious member of the club. Passionate about chess, in 1958 he moved to 28 West 10th Street to live nearer to it.

American chess prodigy and champion Bobby Fischer playing in the Capablanca Memorial tournament via telex at the Marshall Chess Club, August 25, 1965.

FIVE WORKS CREATED BY MARCEL DUCHAMP IN NEW YORK

The Bride Stripped Bare by Her Bachelors, Even (1923)
Rotary Demisphere (1925)
Opposition and Sister Squares are Reconciled (book, with chess champion Vitaly Halberstadt, 1932)
Box in a Valise (1935–41)
Étant donnés (1946–66)

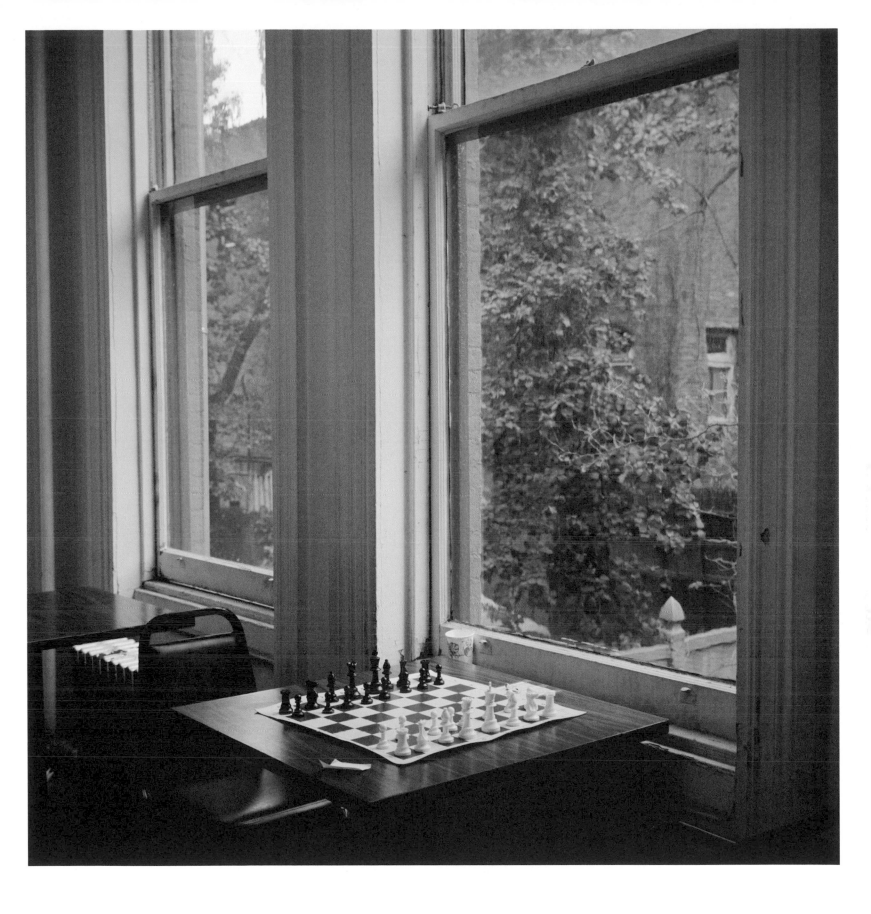

YIPPIE! HEADQUARTERS

FIGHT THE POWER

Home of the revolution

On December 31, 1967, Abbie Hoffman, Jerry Rubin, and a few cohorts founded the Youth International Party (aka Yippies, or Yippie!), a revolutionary countercultural organization dedicated to free speech and anti-war protest. The team made 9 Bleecker Street, a three-story brick building in the East Village, the official Yippie! headquarters. Originally a cigar factory, the building also hosted organizations such as the newspapers *Overthrow* and the *Yipster Times,* the National AIDS Brigade, the US Medical Marijuana movement, and Million Marijuana March, as well as the Lenny Bruce Academy of Sick Comedy. Known since 2007 as the Yippie Museum Café, the building was foreclosed in January 2014 to make way for new tenants.

American social and political activist Dana Beal at 9 Bleecker Street, 1960.

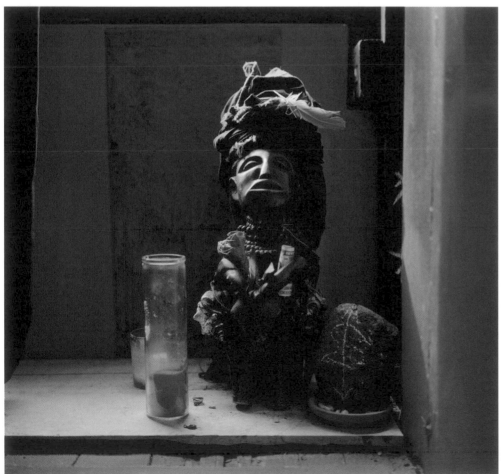

FIVE BOOKS BY ABBIE HOFFMAN AND JERRY RUBIN

Abbie Hoffman, *Revolution for the Hell of It*
 (New York, 1968)
Abbie Hoffman, *Soon to be a Major Motion Picture*
 (New York, 1980)
Abbie and Anita Hoffman, *To America with Love:*
 Letters from the Underground (New York, 1976)
Jerry Rubin, *Do It! Scenarios of the Revolution*
 (New York, 1970)
Jerry Rubin, *We Are Everywhere:*
 Written in Cook County Jail (New York, 1971)

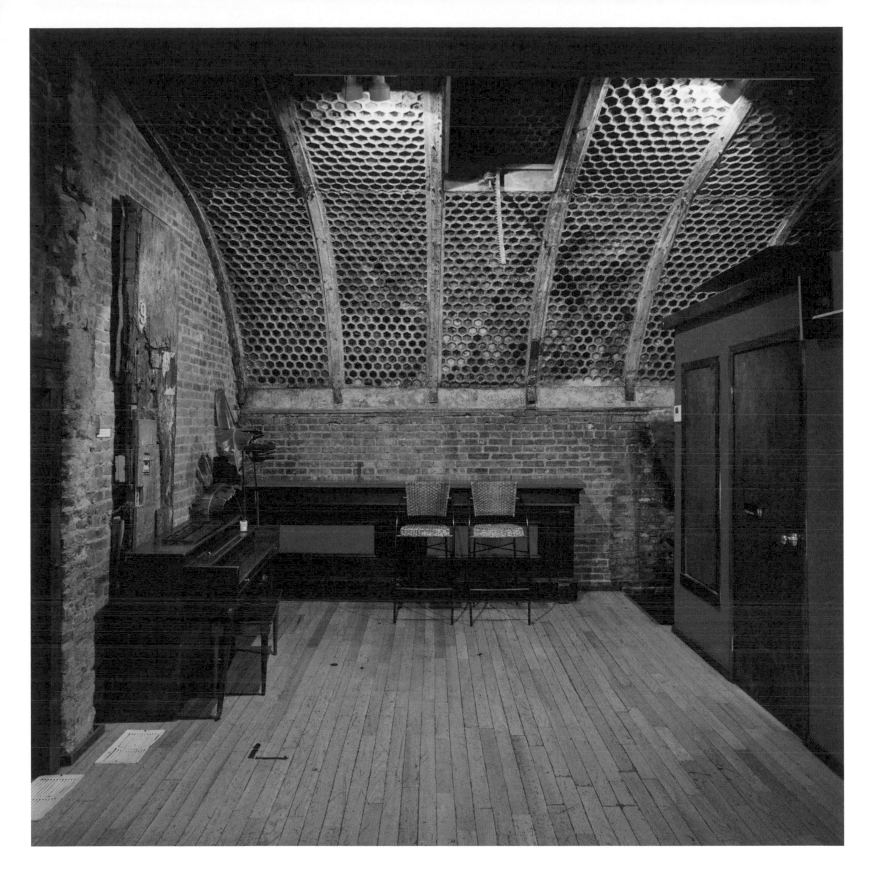

GASLIGHT CAFÉ

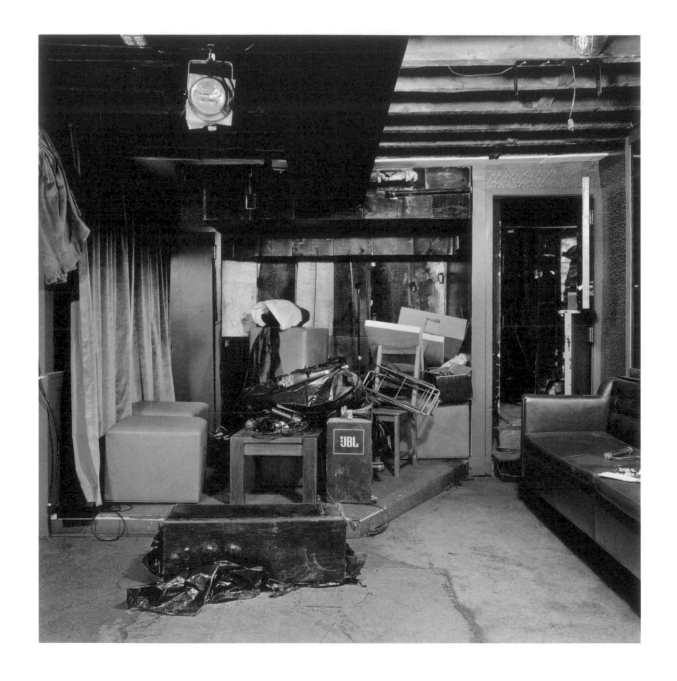

JUST FOLK

Where Bob Dylan and many others made their debuts

A basement with little light, no reserved tables in front of the stage, and so few seats available that the crowd often stood wedged against a brick wall. Add to this a suffocating heat and thick smoke and you have a picture of what used to be one of the most popular Greenwich Village bohemian hangouts of the late 1950s.

Located near Kettle of Fish and Izzy Young's Folklore Center, the Gaslight Café was founded in 1958 by John Mitchell; Clarence Hood then bought it from Mitchell in 1961 and ran it with his son Sam as a folk club. It remains famous for hosting influential figures such as writer LeRoi Jones (Amiri Bakara), poet Diane di Prima, Beat poets Allen Ginsberg and Gregory Corso, and a young Bob Dylan, who famously gave his very first serious gigs here with the support of folk singer and well-known Greenwich Village figure Dave Van Ronk.

Extraordinarily popular despite its major lack of creature comforts, the Gaslight Café was also famous for consistently breaking safety rules: every night, hundreds of customers were crowded into the narrow room; it was regularly visited by fire-fighters. In order to not see Richie Havens's or Len Chandler's concerts interrupted by the police, the audience would lock the door. And, as noted by Kristin Baggelaar and Donald Milton in *Folk Music Encyclopedia* (1977), "The Gaslight was weird then because there were air shafts up to the apartments and the windows of the Gaslight would open into the air shafts, so when people would applaud, the neighbors would get disturbed and call the police. So then the audience couldn't applaud; they had to snap their fingers instead."

The Gaslight eventually closed in 1971, and the building is disused today.

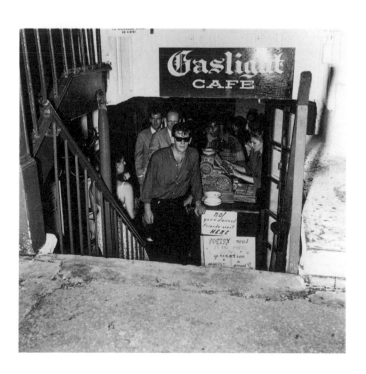

Entrance to the Gaslight Café, 1960. Below the cash register it says, "No! Your damned friends aren't here."

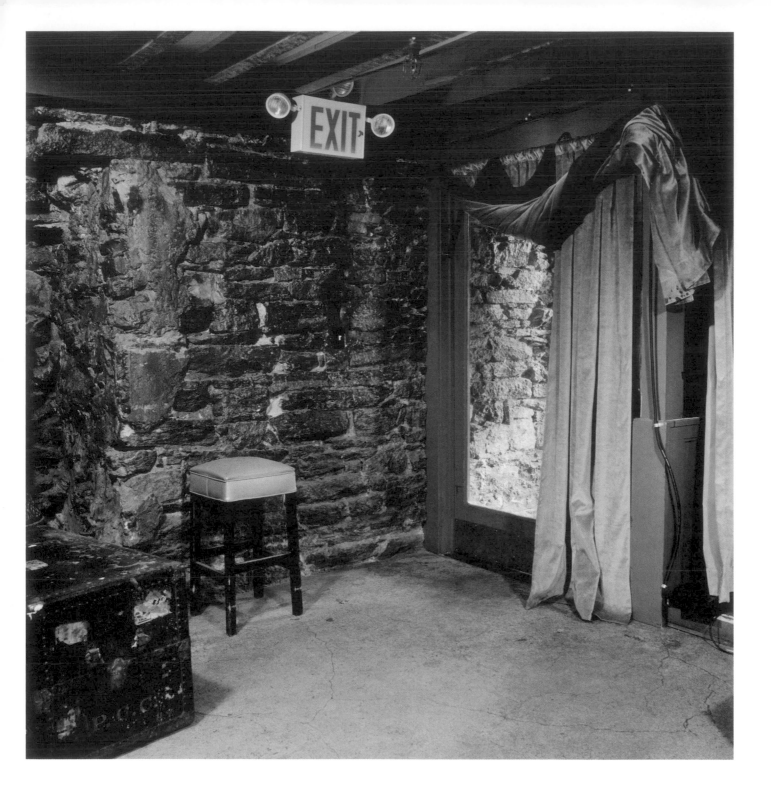

FIVE TRACKS BY BOB DYLAN
RECORDED LIVE AT GASLIGHT CAFÉ

"Song to Woody" (1961)
"He was a Friend of Mine" (1962)
"It's Hard to be Blind" (1962)
"Man on the Street" (1962)
"Talkin' Bear Mountain Picnic Massacre Blues" (1962)

EL QUIJOTE

THE CHELSEA HOTEL'S UNOFFICIAL CANTEEN
Spanish restaurant frequented by
Chelsea's artistic greats

Opened in 1930 next to the Hotel Chelsea (or Chelsea Hotel), El Quijote is now a National Historic Landmark. Sporting walls covered with Andalusian folklore images and known for serving the freshest lobsters in New York, this Spanish restaurant also owes its glorious reputation to some prestigious guests. In the 1960s and '70s, its two dining rooms welcomed some of American counterculture's greatest heroes, who stopped in while they were staying at the Chelsea. These included Allen Ginsberg, Janis Joplin, Leonard Cohen, Robert Mapplethorpe, and Patti Smith.

At the time of writing, El Quijote continues to offer the same historic, old-New York dining experience to its patrons as it has for over 80 years.

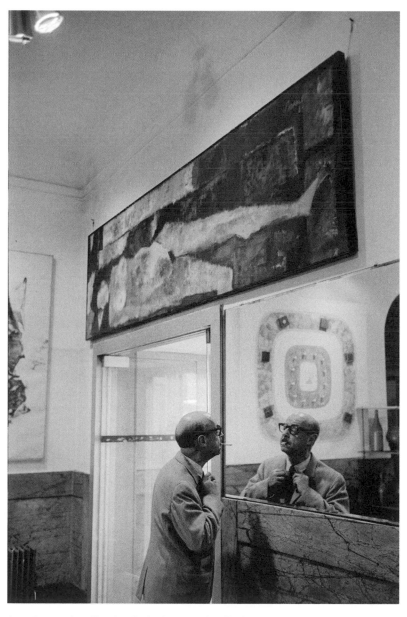

American writer Charles R. Jackson at the Chelsea Hotel, where he committed suicide in 1968. On the left is the secret door that leads directly from El Quijote to the hotel.

FIVE LANDMARK EVENTS AT THE CHELSEA HOTEL

Dylan Thomas falls ill, before dying in hospital, November 9, 1953
Andy Warhol and Paul Morrissey film *Chelsea Girls*, summer 1966
Charles R. Jackson commits suicide, September 21, 1968
Arthur C. Clark writes *2001: A Space Odyssey*, 1964 (published 1968)
Nancy Spungen murdered by Sid Vicious, October 12, 1978

&

Biographies

David Brun-Lambert is an authority on pop culture and modern cultural avant-gardes. He is the author of several books, including the biography *Nina Simone: A Life* (2005) and *Electrochoc* (with DJ Laurent Garnier, 2013). He was previously Editor-in-chief of the French magazine *Les Inrockuptibles Hors Série* and served as Editorial Director of the exhibition 'Great Black Music' at the Philharmonie de Paris (2014). He has produced radio programs for Radio Nova, France Culture, and Radio Télévision Suisse. Also a screenwriter, Brun-Lambert co-wrote the feature film *Electrochoc* (production is scheduled for 2015) and wrote the documentary *Dance Your Blues Away: A History of the Dancefloor*, currently in production for the TV network Arte France. He lives in Geneva.

John Short is a London-based photographer known internationally for his still-life imagery. As a counterbalance to his time spent in the studio, Short travels widely in search of those special scenes that he feels compelled to commit to film. Whether he's shooting the back streets of Paris, the glaciers of Greenland, or the expanses of the Australian desert, Short creates captivating images that challenge the common perception of what one would expect to find in such places.

David Tanguy is Creative Director of the London design studio Praline, which he founded in 2000. He has created numerous successful projects worldwide, encompassing graphic design to branding, exhibitions, and art direction. Praline has grown into a trusted and well-respected agency, having worked with clients including Tate Modern, the Royal Academy of Arts, the Design Museum, Central Saint Martins, The Barbican, Rogers Stirk Harbour + Partners, Heston Blumenthal, and many others. Tanguy has designed numerous books for international publishers and art galleries, and his work has been recognized with awards from D&AD, the Art Directors Club, the Royal Society of Arts, and the British Book Design and Production Awards.

Picture Credits

All photographs © John Short, with the exception of the archival images:

Page 13 © Waring Abbott/Getty Images; p. 17 © Robin Platzer/Twin Images/The LIFE Images Collection/Getty Images; p. 23 © Fred W. McDarrah/Getty Images; p. 27 © John Roca/NY Daily News Archive via Getty Images; p. 31 © Bettmann/Corbis; pp. 34, 36 top © Dieter Roth Estate, courtesy of the Dieter Roth Estate and Hauser & Wirth; p. 35 © Janette Beckman/Getty Images; p. 37 © Martin Creed, courtesy of the artist and Hauser & Wirth; p. 39 © Tim Boxer/Getty Images; p. 43 © Bettmann/ Corbis; p. 49 © Sokol New York; p. 55 © Ebet Roberts/Redferns; p. 59 © Drew Stone; p. 63 © Hy Rothman/ NY Daily News Archive via Getty Images; p. 67 © Tom Marcello; p. 71 © James Garrett/NY Daily News Archive via Getty Images; p. 75 © Verna Gillis; p. 81 © Amy Greenfield/Anthology Film Archives; p. 85 © Gretchen Berg/Anthology Film Archives; p. 89 © Fred W. McDarrah/ Getty Images; p. 93 © Geno Rodriguez; p. 97 © Vivian Selbo; p. 101 © Senga Nengudi; p. 105 © Jim R. Moore/Vaudevisuals.com; p. 109 © Kathy Landman; p. 113 © Fred W. McDarrah/Getty Images; p. 117 © Fred W. McDarrah/Getty Images; p. 121 © Truman Moore/The LIFE Images Collection/Getty Images; p. 125 © Sam Falk/New York Times Co./Getty Images; p. 131 © Rose Hartman/Getty Images; p. 135 © Victor Bockris/Corbis; p. 141 © John Loengard/The LIFE Picture Collection/Getty Images; p. 145 © Misha Erwitt/NY Daily News Archive via Getty Images; p. 149 © Fred W. McDarrah/Getty Images; p. 153 © Patrick A. Burns/New York Times Co./Redux/laif; p. 159 © Maripol; p. 163 © Fred W. McDarrah/Getty Images; p. 167 © Marvin Koner/ Corbis; p. 171 © Neal Boenzi/New York Times Co./Getty Images; p. 175 © John Olson/The LIFE Premium Collection/Getty Images; p. 179 © Fred W. McDarrah/Getty Images; p. 183 © Bettmann/Corbis.

Acknowledgments

The authors would like to give special thanks to: Jonas Mekas, John Giorno, James Murphy, Gregory Sholette, Maripol, Verna Gillis (Soundscape), Ali Gitlow, Aimee Selby, and Prestel Publishing.

We also wish to thank for their help and contribution:

Doug Abraham (Steve Schul)
Arnie Apostol and Suzy Upton (Martha Graham
 Center of Contemporary Dance)
Brian Barnhart (Axis Theatre Company)
Barrow Street Ale House (and Michael)
Barbara Baruch (Brooke Alexander)
Justine Birbil (Michael Werner Gallery)
Peter Blachley (Morrison Hotel Gallery)
Rachel Bolle
Ed Chlanda and Andrea (Sokol Hall)
Ellie Covan (Dixon Place)
Paul Donzella
Isabelle Dufresne
Peter Esmond (Rouge Tomate)
Dr. Marcus Fenner and Alex King (Marshall Chess Club)
Christopher Fischer and Charlene Kuo
Carlos Fragoso
Deborah Gordon (Village Vanguard)
Leslie Grunberg
David Hall (Harmony Kitchen)
Hauser & Wirth, New York
Foofwa d'Imobilité
Nicholas Jarecki
Jay Johnson (St. Mark's Church in-the-Bowery)
François Kevorkian
Chiyomi Koike
Kathy Landman
Claire Le Breton
Joanne Loria (The Joester Loria Group)

Legs McNeil
Tom Marcello
Michael Werner Gallery
Nicole and The Poetry Project
Glenn O'Brien
Eric Osbun (Westside Theatre)
Lorcan Otway (Theatre 80 St. Marks)
Jose Perez (El Quijote)
Matt Polk, Jessica Johnson and Roundabout Theatre Company
Barbara Poolin (Pac Lab)
Alex Prat
Geno Rodriguez (The Alternative Museum)
Paul Russell and Melissa Jameson (Judson Memorial Church)
Mike Salinari (Stonewall Inn)
Julie Schumacher
Peter Shapiro
Austin Smedstad (John Varvatos)
Nancy Stewart and Grace Polk (Eighth Church of Christ, Scientist)
Drew Stone
Gail Thacker (Gene Frankel Theatre)
John Varvatos
Madeline Warren
Jimmy Webb
Lynn Wichern (Merce Cunningham Trust)
Johnny Yerington (A7)

David Brun Lambert would like to thank:
David Beaugier, Marc Bénaïche, Claire Burgy, Danielle and Laure Brun,
Clément Charles (AllTheContent), Marc Emery, Xavier Guennan,
Olivier Horner, Vanessa Horowitz, Pauline Lallondrelle, Claire Le Breton,
Laïla Marrakchi, François-Xavier Roy, Shandira Son, Maruschka Vidovic,
Benoit de Vilmorin. *To Martha and Ava.*

John Short would like to give special thanks to:
Russell Kirby for all his great retouching and Ollie Jarman
for his expert assistance.

David Tanguy would like to give a big thank you to:
Ali Gitlow at Prestel for her fantastic support, Lawrence Weiner for
his very moving Foreword, Louisa Elderton at Blain|Southern for her
help, and the Praline team for the amazing design: Romilly Winter,
Sarah Krebietke, David Bate, Al Rodgers, and Cecilia Thomas.

© Prestel Verlag, Munich · London · New York, 2015
© for the text by David Brun-Lambert, 2015
© for the photographs see Picture Credits, p. 189, 2015

Prestel Verlag, Munich
A member of Verlagsgruppe Random House GmbH

Prestel Verlag
Neumarkter Strasse 28
81673 Munich
Tel. +49 (0)89 4136-0
Fax +49 (0)89 4136-2335

www.prestel.de

Prestel Publishing Ltd.
14–17 Wells Street
London W1T 3PD
Tel. +44 (0)20 7323-5004
Fax +44 (0)20 7323-0271

Prestel Publishing
900 Broadway, Suite 603
New York, NY 10003
Tel. +1 (212) 995-2720
Fax +1 (212) 995-2733

www.prestel.com

Library of Congress Control Number: 2015936427
British Library Cataloguing-in-Publication Data:
a catalogue record for this book is available from
the British Library; Deutsche Nationalbibliothek
holds a record of this publication in the Deutsche
Nationalbibliografie; detailed bibliographical data
can be found under: http://dnb.d-nb.de

Prestel books are available worldwide. Please contact
your nearest bookseller or one of the above addresses
for information concerning your local distributor.

Editorial direction: Ali Gitlow
Copy-editing: Aimee Selby
Design and layout: David Tanguy, Praline
Production: Friederike Schirge
Origination: Reproline Genceller, Munich
Printing and binding: DZS Grafik, d.o.o., Ljubljana

Printed in Slovenia

ISBN 978-3-7913-8134-3

Verlagsgruppe Random House FSC® N001967

The FSC®-certified paper Tauro has been supplied
by PapierUnion, Germany